IMAGES
of America

BROOK PARK

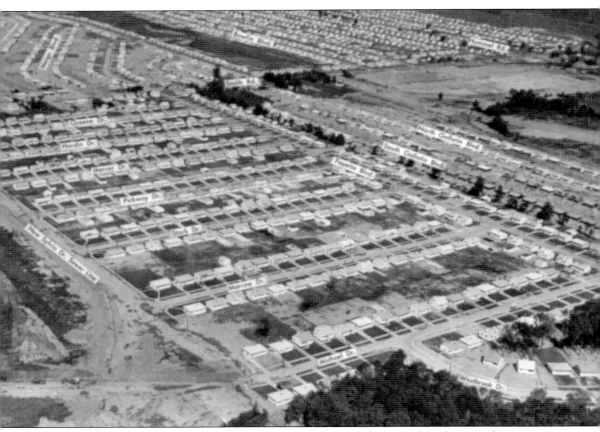

BROOK PARK CITY, 1959. This aerial view illustrates the growth of Brook Park city with an average increase of 2,000 residents per year. On the fringes of the photograph are the last traces of the fields and woods that were once part of a rural setting. (Courtesy of Cleveland Memory Project.)

ON THE COVER: BROOK PARK ROAD BRIDGE DEDICATION, 1934. The cover image shows the dedication of the Brook Park Road Bridge on June 30, 1934, with Evelyn Mares cutting the ribbon with the presence of Gov. George White, Brook Park mayor Louis Mares, Parkview mayor David Baine, and other local officials. The dedication was an illustration of a state-and-local partnership. (Courtesy of Cuyahoga County Public Library.)

IMAGES
of America

BROOK PARK

Dr. James Van Keuren

ARCADIA
PUBLISHING

Copyright © 2023 by Dr. James Van Keuren
ISBN 978-1-4671-0997-0

Published by Arcadia Publishing
Charleston, South Carolina

Printed in the United States of America

Library of Congress Control Number: 2023931262

For all general information, please contact Arcadia Publishing:
Telephone 843-853-2070
Fax 843-853-0044
E-mail sales@arcadiapublishing.com
For customer service and orders:
Toll-Free 1-888-313-2665

Visit us on the Internet at www.arcadiapublishing.com

CONTENTS

ACKNOWLEDGMENTS

I would like to first thank my wife, Pat, once again, for her patience and encouragement during my lengthy hours of research and writing. A thank-you is owed to Brian Meggitt, of the Cleveland Public Library/Photograph Collection Center, who was timely in providing photographs for the book. Shayna Muckerheide, former director of the Brook Park Branch of the Cuyahoga County Public Library, was helpful in identifying early photographs of the village of Brook Park. Jan Wittry, the news chief of NASA Glenn Research Center, provided guidance on the use of photographs from the research center's website, Mandi Goodsett, of Michael Schwartz Library, Cleveland State Library, did the same with the use of the photographs from the Cleveland Memory Project. I'd like to thank David Jackson, of usautoindustryworldwartwo.com, for providing Army tank photographs for the book. Thanks go to Lisa Rienerth, library associate for Medina County District Library, for information about the Medina Tank Testing Ground. United Auto Workers (UAW) Local No. 1250 allowed me to use photographs from *The Cleveland Site: History 1950–1997* book to tell the Ford Motor Company story in Brook Park.

Appreciation goes to Bryan Miller of for assisting in framing the photographs. Thanks go to Arcadia Publishing's Jeff Ruetsche for moving the book proposal forward and Amy Jarvis for her patience and guidance through the publication process. Finally, a special thank-you is owed to Michael Gammella for allowing me to tell his story as union president of UAW Local No. 1250 and the mayor of Brook Park City, Ohio.

INTRODUCTION

Brook Park City, Ohio, is a community of 7.53 square miles with a broad outreach in the greater Cleveland area with the opening of a municipal airport in 1925. At one time, there were 6,000 workers at the Cleveland Bomber Plant, 10,000 at the Cleveland Tank Plant, 15,000 at the three Ford Motor Company plants, and today, 3,000 at the NASA Glenn Research Center.

Cleveland Municipal Airport, now known as the Cleveland Hopkins International Airport, was built on the open fields of the village of Brook Park. It is known for being the oldest municipal airport in the United States (1925) still in operation at the same location; for hosting the First National Air Races (1925); and for having the first airfield lighting system (1925), the first air traffic control tower with airplane-to-tower radio system in the United States (1930), and first passenger scheduling board (1930). All of this happened in the backyard of the village of Brook Park.

The start of World War II launched new industrial sites across the country to meet the war-production demand, and the village of Brook Park was a major contributor. The Cleveland Aircraft Assembly Plant No. 7 in 1942 was known by multiple names, such as Fisher Body Aircraft Plant No. 2, and was commonly known as the Cleveland Bomber Plant. The plant was 2,270,000 square feet and was built without any windows so that it could be completely blacked out to disguise it from potential enemy bombers. The plant manufactured Boeing's B-29 Superfortress bombers' airframe components, and it was said that it was the largest plant in the United States supplying parts to aircraft assembly plants.

At the conclusion of World War II, the Cleveland Aircraft Assembly Plant No. 7 was used for soybean storage, the 1946 National Aircraft show, and two post–World War II National Air Races. In 1950, with the start of the Korean conflict, the US War Department designated Cadillac Division of Motors to reopen the plant into a tank and armored vehicle manufacturing plant. The tank plant employed over 6,000 people at peak production, which added jobs and stoked the local economy for Brook Park and the greater Cleveland area. With the airport and railroad lines nearby, the Cleveland Tank Plant took advantage of the easy access to these forms of transportation.

In the early 1950s, General Motors created the Walker Bulldog tank with a new gun sight, and it was used in the Korean War. The plant closed in 1959 and reopened in 1960 as the Cadillac Tank Plant and built self-propelled T-195 howitzers. A field-testing site was created 15 miles south of the plant, near Hinkley, Ohio, where the terrain tested the maneuverability of the armored vehicles. The photographs in chapter five show some of the tanks and armored vehicles that were built at the plant from 1950 to 1972.

The Aircraft Engine Research Laboratory, which served as the National Advisory Committee for Aeronautics (NACA) research laboratory, broke ground in the village of Brook Park in January 1941, and during World War II, NACA played a major role in producing working superchargers for high-altitude bombers, which was accomplished by the creation of an Altitude Wind Tunnel. The tunnel was used to correct problems of the engine cooling system, as in the Boeing B-29 Superfortress, and made it possible for the *Enola Gay* to bomb Hiroshima on August 6, 1945.

Over the years, the National Advisory Committee Aeronautics became involve with space exploration where the laboratory worked on the use of liquid hydrogen rocket fuel and technological advancement in spaceflight systems development. Most notably was NACA's work on Project Mercury the nation's first crewed space program. Today, NACA is known as the NASA Glenn Research Center in Book Park and Cleveland, Ohio.

Ford Motor Company built its second-largest manufacturing vehicle facility in Brook Park with the opening of Engine Plant No. 1 (1952 to present), Casting Plant (Foundry 1952–2010), Engine Plant No. 2 (1955–2012), and an Aluminum Casting Plant (2000–2003). The Casting Plant was a foundry that made engine blocks for the engines being manufactured at the two engine plants. At the peak of production in the 1970s, the plants employed over 15,000 workers with 10,000 working at the Casting Plant.

Local No. 1250 of the United Auto Workers (UAW) played an important role in maintaining competitive wages and a safe work environment for its members over the years. The union was able to partner with management to make the Ford Motor Company's second-largest site a success in manufacturing over 35 million engines for its cars and truck. UAW Local No. 1250 built a union hall in 1956 with an activity hall that could seat 600, an area for recreation activities, and a retiree lounge with a wood fireplace.

Today, Engine Plant No. 1 is the only Ford plant remaining in Brook Park with over 1,700 employees. The plant's current products are 20/2.3-liter EcoBoost engines used in the new Ford Mustang and the 3.5-liter EcoBoost V-6 engines that are used to power midsize and full-size cars, pickups, supercars, and SUVs.

The Brook Park industrial revolution started in 1942 with opening of the Cleveland Aircraft Plant No. 7, and at that time, the population of village of Brook Park was 1,122. In 1960, with the opening of the three Ford plants and the Cadillac Tank Plant, the population grew to 12,856, or a 393-percent increase. At its industrial peak in 1979, Brook Park's population grew to 30,774, or an increase of 139 percent. Today, the population has leveled off to 18,595.

This past industrial activity reflects a little-known role that Brook Park played during World War II, the Korean War, the Vietnam War, space technology, vehicle manufacturing, and becoming an airport center that eventually spread over one square mile. Most people believe that the vital commerce sector was in Cleveland, Ohio, but no, it was in Brook Park, Ohio, making it a commerce leader.

So, let us explore the Images of America where a rural community became an industrial hub and innovation center with the assistance of local resident Michael Gammella, a leader in industrial and community relations who, as the union president of UAW Local No. 1250 and the mayor of Brook Park City, strived to move the community forward during some uncertain times.

One

EARLY BEGINNINGS

The area known today as Brook Park City, Ohio, was seamless farmland, and at the start of the Civil War in 1861, it was settled by German farmers. The farmers came to secure freedom that was being denied in Germany. Through the late 1800s, Brook Park was originally part of Middleburg Township and was incorporated as the Village of Brook Park on June 3, 1914. The name Brook Park was chosen in remembrance of a creek that was buried by development. The first election of officials was as follows: William J. Sifleet, mayor; S.H. Pincombe, clerk; F.E. Landphair, treasurer; John Greenwald, William Bauer, Louis Grosse, W.C. Schmidt, Frank Taft, and John Meermans, councilmen. The council's first meetings were held on the second floor of Henry Zutavern's tavern, and they paid rent of $6.

In 1915 and 1916, the village of Brook Park had a mini-gas boom with wells being dug on farmland. The wells went approximately 2,600 feet deep and could cost as much $12,000 per well. If a well came in, the farmer may have received one-sixth of the proceeds or a flat sum.

The Village of Brook Park's police department did not have a jail; this did not create a problem since permission was acquired to use the neighboring Village of Berea's jail. One catch was that if the prisoner was a woman, they would have to go to the county jail in Cleveland. Until September 1922, the police department's only form of transportation marshal Henry Wensink's horse and buggy; the department next obtained a motorcycle with a sidecar, which helped to balance the cycle on the rutted roads.

As the seamless farmland began to disappear, it led to a more industrialized area. Early photographs serve as a reminder of how people lived in the 1900s in a rural environment that eventually led to a more modern changing society, especially with the creation of the Cleveland Municipal Airport, Cleveland Bomber Plant, Cleveland Tank Plant, NASA Glenn Research Center, and the opening of the three Ford Motor Company plants in the 1950s.

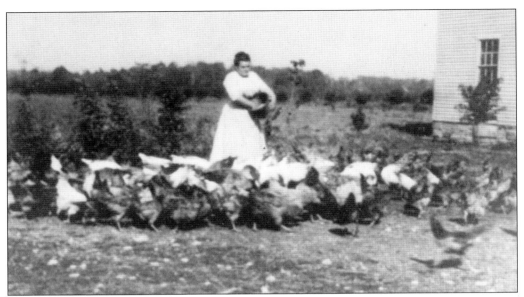

HOMESTEAD, 1900s. The photograph shows a local feeding chickens at her homestead in rural Brook Park. Most farms were not big enough to be profitable to own farm equipment, so machinery would be hired, and the farmers would help each other to harvest wheat and other produce. (Courtesy of Cuyahoga County Public Library.)

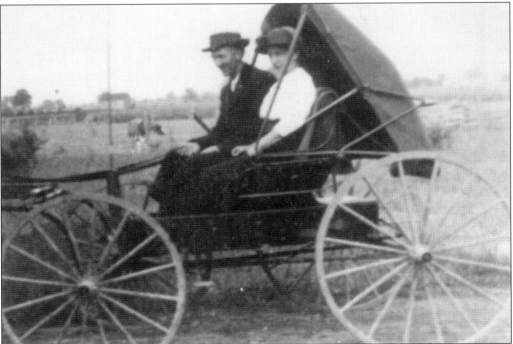

HORSE AND BUGGY, 1900s. The photograph shows a couple riding their horse and buggy on a dirt road in the open farmland of Brook Park. This was the only means of transportation at that time other than a rail line that ran through the village until 1926. (Courtesy of Cuyahoga County Public Library.)

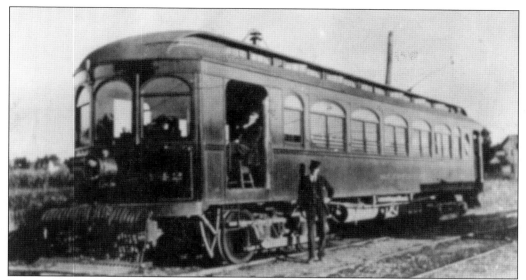

RAILROAD CAR, 1900s. The photograph shows a Cleveland Southwestern passenger car waiting to be switched at the junction of Hummel Road and Riverside Drive at Stop No. 191 in the village of Brook Park. The rail line was used to go to Cleveland. (Courtesy of Cuyahoga County Public Library.)

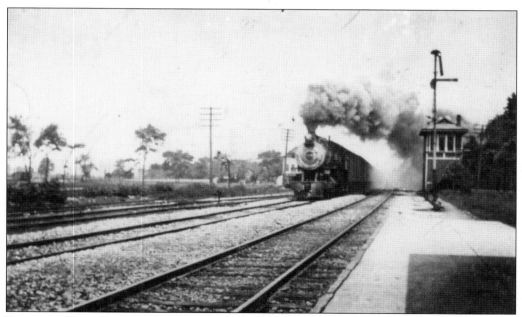

PASSENGER TRAIN, 1900s. The photograph shows a passenger train speeding by a control tower as it was passing through the rural areas of the villages of Brook Park and Berea. Eventually, the train traveling through Brook Park was discontinued in 1926, and people reverted back to using a horse and buggy. (Courtesy of Cuyahoga County Public Library.)

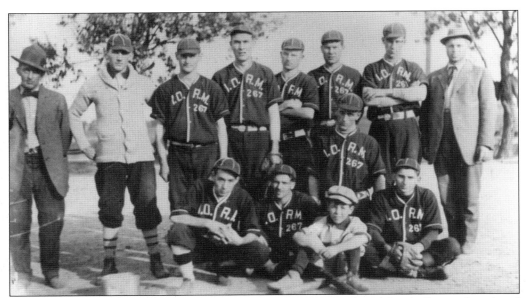

BROOK PARK BASEBALL TEAM, 1910. The photograph shows a Brook Park baseball team that played in neighboring villages, and it appears that the team had a minimum number of players. The team had a large following since it was a major community event when it played in Brook Park. (Courtesy of Cuyahoga County Public Library.)

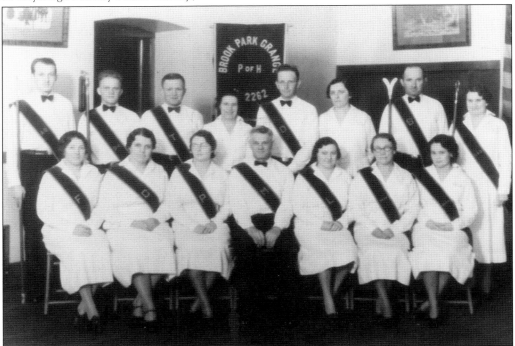

GRANGE DEGREE TEAM, 1920. The photograph shows the Brook Park Grange Degree Team No. 2222 chartered in January 1920, which, at that time, was a civic and social organization that linked a rural village with an industrial city like Cleveland, Ohio. Today, the degree programs are defined in four ritualistic areas that promotes good faith outreach. (Courtesy of Cuyahoga County Public Library.)

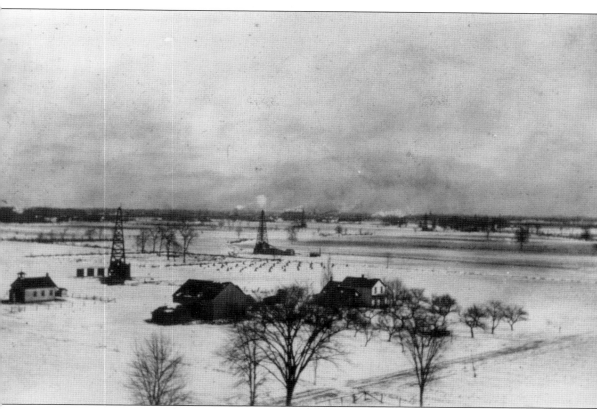

GAS WELL BOOM, 1916. The photograph shows gas derricks visible in the northeast section of Brook Park. Many of the area farms had two and three gas wells on their property. On July 2, 1915, the council passed an ordinance granting the Berea Pipe Line Company the right to lay, operate, and maintain pipes in Brook Park for the purpose of supplying natural gas to the village. The permit fees for the wells helped to build up the treasury of the village. On September 5, 1915, another ordinance was passed to allow the East Ohio Gas Company to come into the village for the purpose of connecting the gas wells located on the farms and taking the gas from them. It was said that the land looked like a mini-Oklahoma with numerous riggings reaching into the sky. (Courtesy of Cuyahoga County Public Library.)

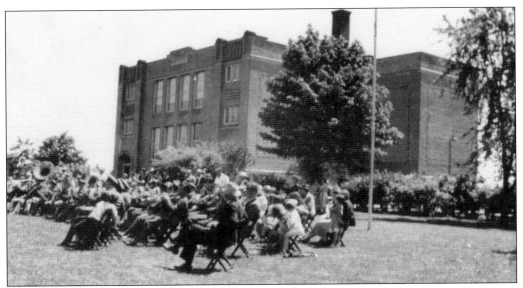

ELEMENTARY SCHOOL, 1916 AND 1918. The photograph above shows a band concert in 1916 at the Brook Park Elementary School at Five Points and Riverside Drive, and the other photograph shows the elementary school teaching staff of 1918, from left to right, Jessie Gray, Laura Lechner, Frank Blair (principal), Addie Reublin, and Sarah Green. Prior to the Brook Park Elementary School, there were 10 school districts scattered throughout the Middleburgh Township. The schools were usually one big room with a round oak stove in the middle and had separate entrances for boys and girls where they sat apart inside the school house. The school books were bought by the parents, and pencils were used to the last piece of lead. Many of the teachers were from the immediate area of Middleburg Township and surrounding communities. (Both, courtesy of Cuyahoga County Public Library.)

ELEMENTARY SCHOOL, 1916. The photograph shows the front view of Brook Park Elementary School, which not only housed students, but also served as a council hall and social center. Until the council built its own facility, the school served as a perfect location for its meetings. (Courtesy of Cuyahoga County Public Library.)

ELEMENTARY SCHOOL, 1918. The photograph shows Brook Park Elementary School graduates of the class of 1918. This was the first graduating elementary class since the establishment of a standalone school in the village of Brook Park. This was the start of formal graduation at the elementary school. (Courtesy of Cuyahoga County Public Library.)

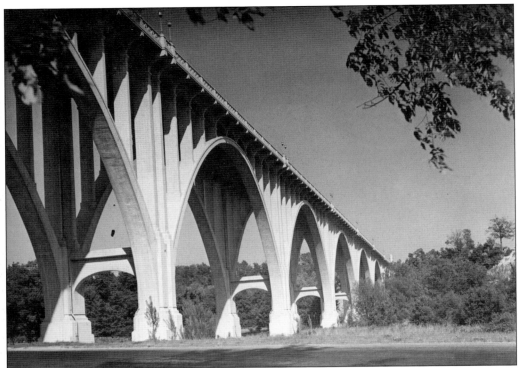

BROOK PARK ROAD BRIDGE, 1938. The photograph shows the ground-level view of the bridge featured on the book cover. The 1,918-foot span carried Route 17 over Rocky River Valley near the Cleveland Municipal Airport. It was built at a cost of $383,767 and is 40 feet wide and 120 feet high. (Courtesy of Cleveland Public Library/Photograph Collection.)

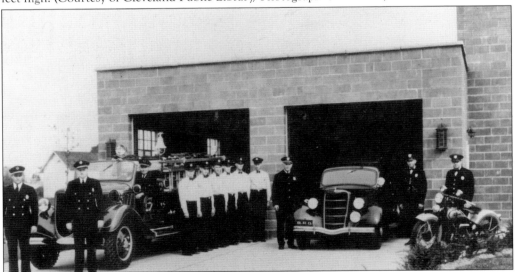

VOLUNTEER FIRE DEPARTMENT, 1937. The photograph shows Brook Parks first fire department. The fire department readiness was needed during the Cleveland National Air Races. Prior to this, the village arranged for protection for the entire community with Berea and paid $150 per call. (Courtesy of Cuyahoga County Public Library.)

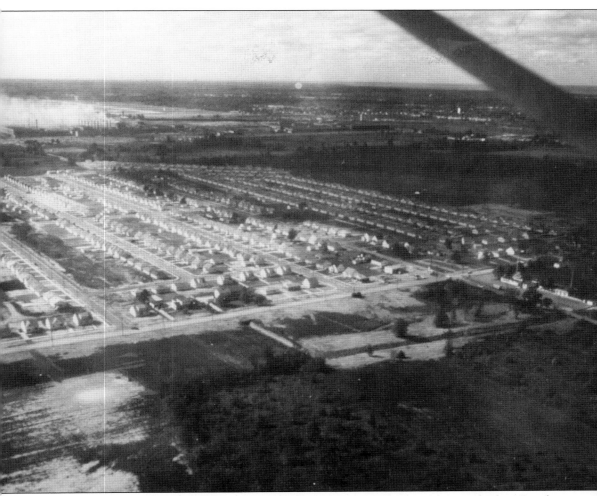

NEW INDUSTRIAL HUB, 1950s. The photograph shows a section of housing that was built in Brook Park to accommodate the employees of the three Ford Motor Company plants. The construction of the Ford Casting Plant in 1951 marked a major milestone in Brook Park's postwar boom. The farmland gave way to housing developments where light industry found the advantages of Brook Park's open fields and its closeness to the Cleveland Municipal Airport, which made it ideal for industrial growth. With the opening of the Casting Plant in 1951, Engine Plant No. 1 in 1952, and Engine Plant No. 2 in 1955, it led to a mini-housing boom. In the 1950s, the village administration was looking for a new site to build another city hall since the airport expansion was too close to the existing city hall. (Courtesy of Cuyahoga County Public Library.)

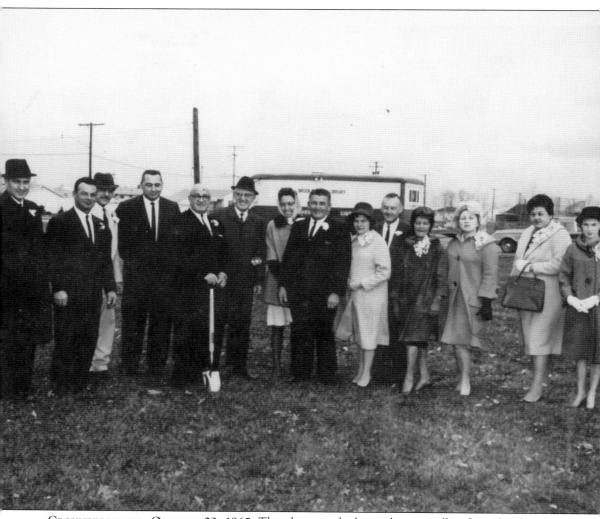

GROUNDBREAKING, OCTOBER 23, 1965. The photograph shows the groundbreaking for the new Brook Park Library. On May 4, 1965, voters approved a 1.5 mill levy for the library with the federal government contributing a $75,000 grant toward the $225,000 for the 13,225-square-foot building. The library was dedicated on December 18, 1966, and opened on January 23, 1967. Prior to the new building, the Brook Park community library started on June 13, 1963, in an old bookmobile car on cement blocks in the parking lot of the police station. The bookmobile was open on Tuesdays and Thursdays from 1:00 p.m. to 9:00 p.m., and people had to stand outside in line because the bookmobile could only accommodate 10 people. Thelma Kalusza, the first librarian, went out into the community to retrieve overdue books. (Courtesy of Cuyahoga County Public Library.)

Two

CLEVELAND MUNICIPAL AIRPORT

The village of Brook Park, Ohio, a rural community with acres of open land, started to be transformed in 1925, when William R. Hopkins, Cleveland city manager, selected a site for the Cleveland Municipal Airport (Cleveland Hopkins International Airport) in Brook Park's open land. Legal disagreements over the annexation of the airport ended in 1947 with Cleveland paying Brook Park $85,000 for more than 1,000 acres, including the airport.

The Cleveland Municipal Airport is the United States' first and oldest municipally owned airport, having opened on July 1, 1925. It is estimated that over 100,000 people attended the opening ceremony highlighted by flying stunts and activities.

The Cleveland National Air Races started in 1929 with its birth place at the Cleveland Municipal Airport mainly because of the expansiveness of the flying field. The Village of Brook Park airport location brought more than 80 aviation parts suppliers to the area by 1940. The National Air Races brought in some of the fastest airplanes on the cutting edge of aviation technology to the greater Cleveland area. It was said that cars would be lined up 11 miles to the National Air Races. In the closed course events, planes would fly low over farmhouses and barns, damaging roof shingles from prop wash. In September 1949, a plane flown by record-setter Bill Odom crashed into a Berea home, killing a mother and baby; this led to the discontinuation of the National Air Races from the Brook Park scene.

This chapter shows the early images of the Cleveland Municipal Airport; its takeover of Brook Park's open fields started the village's transformation to becoming a major industrial hub in the greater Cleveland area.

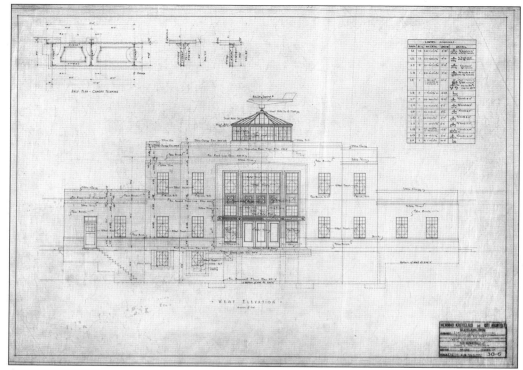

ADMINISTRATION BUILDING DRAWING, 1929. The drawing shows the west end of the Administration Building, construction in 1928 and finished in 1929. This would be one of the first airport terminals in the United States that had a passenger waiting area and control tower. (Library of Congress.)

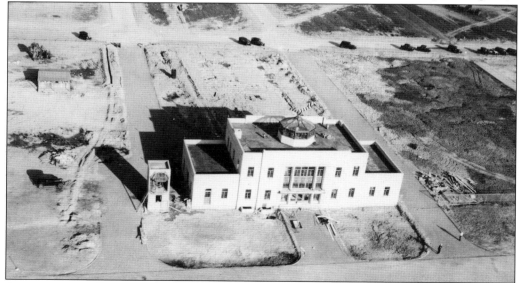

ADMINISTRATION BUILDING, 1929. Surrounded by three roads, the new Administration Building is shown in this aerial photograph. A fourth road with cars parked along it is located at the top of the photograph. The house on left of the building was constructed for a new 300,000-candlepower floodlight. (Courtesy of Cleveland Public Library/Photograph Collection.)

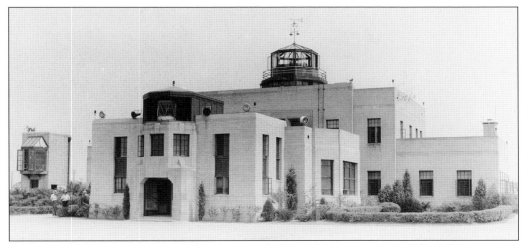

ADMINISTRATION BUILDING, 1937. The photograph shows the exterior view of the Administration Building with the control tower visible that provided two-way radio contact with incoming and outgoing planes. The Administration Building housed a passenger waiting area, restrooms, and a cafeteria, which was ahead of most airports across the country. (Library of Congress.)

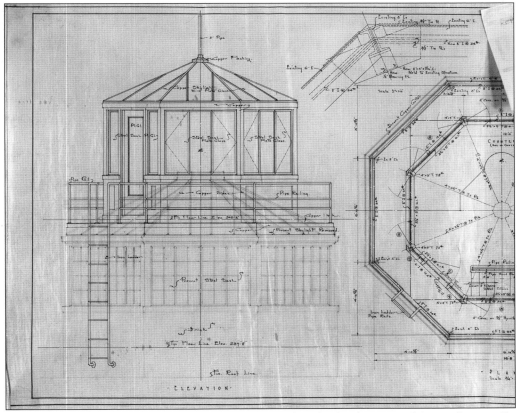

CONTROL TOWER DRAWING, 1935. The drawing depicts the Cleveland Municipal Airport's air traffic control tower. The tower was added to the main terminal and was the first air traffic control tower in the nation that became a model for airports across the country to replicate. (Library of Congress.)

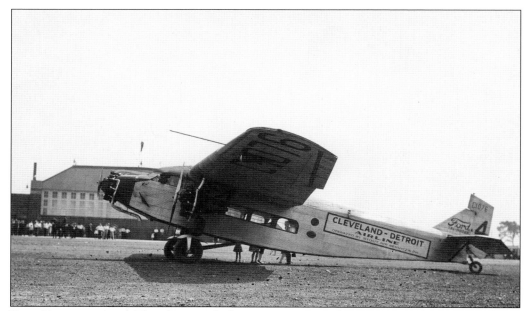

FORD TRIMOTOR, 1928. The photograph shows a trimotor, with spectators and the airport in the background. This plane was part of the Cleveland-Detroit Airline passenger and freight service. The trimotor, nicknamed the *Tin Goose*, was a three-engine transport aircraft. Production of the aircraft was done by Stout Metal Airplane Division of the Ford Motor Company that manufactured 199 trimotors. (Courtesy of Cleveland Public Library/Photographic Collection.)

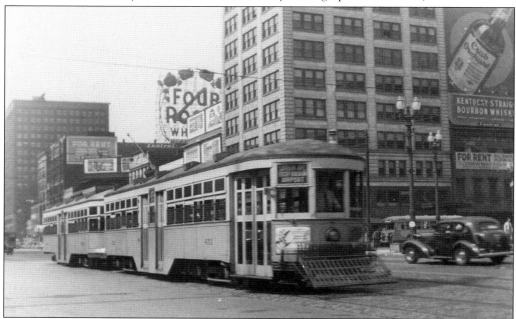

CLEVELAND STREETCAR, 1935. The photograph shows the Lorain Avenue Airport Line streetcar that, for decades, served as primary means of public transportation to the Cleveland Municipal Airport. Streetcars were phased out in the 1940s and 1950s with last the streetcar run on January 2, 1952. (Courtesy of Cleveland Public Library/Photograph Collection.)

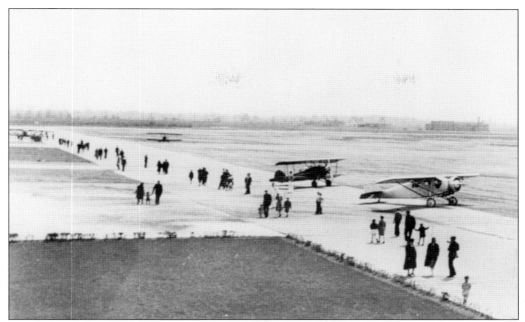

AIRPORT BOARDING AREA, 1937. The photograph provides an exterior view of the boarding area that appears to be on the edge of the runway; it lacked shelter for the passengers waiting to board a plane. Compared to today, the passengers were formally dressed in suits and dresses at that time. (Library of Congress.)

CLEVELAND MUNICIPAL AIRPORT, 1937. The photograph shows a group of spectators watching as NC14277 departs from the tarmac in the background. Note the airline employees inspecting a plane for departure and the passengers boarding from the edge of the runway. (Courtesy of Cleveland Public Library/Photograph Collection.)

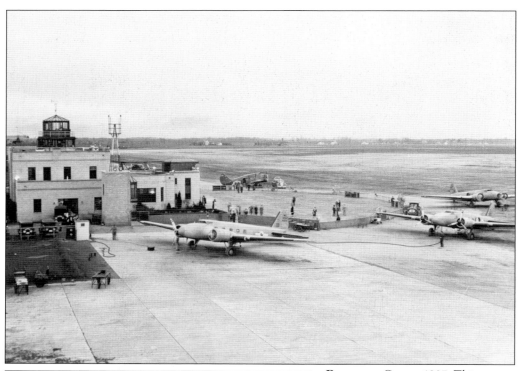

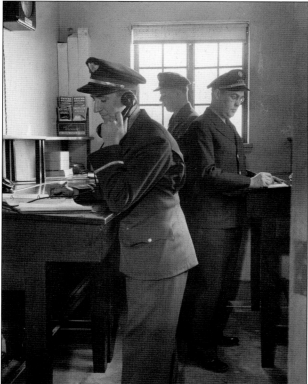

BOARDING GATES, 1937. This photograph shows the Cleveland Municipal Airport, which is the first municipally owned airport in the United States that still is in continuous operation service at the same location since 1925. The airport pioneered air traffic control through a radio-equipped control tower in 1930. (Library of Congress.)

AIRPORT PASSENGER AGENTS, 1937. Three uniform passenger agents are pictured working in a room inside the airport. On the wall, there were timetables for American, Northwest, and United Airlines where the agents were responsible for keeping up with changes, cancellations, and postings changes to the schedule. (Courtesy of Cleveland Public Library/Photograph Collection.)

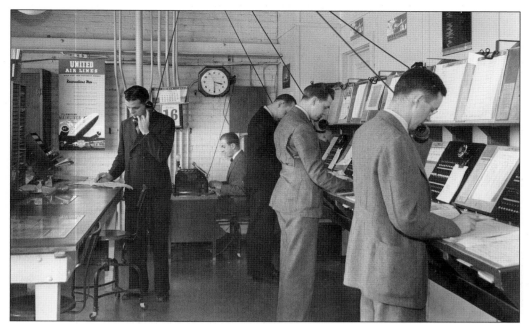

AIRPORT TICKET RESERVATION OFFICE, 1937. Here is an interior view of the ticket reservation office and workers. This was one of three ticket reservation offices at the Cleveland Municipal Airport where trips were planned for those traveling by air by working with the airlines at the airport. (Courtesy of Cleveland Public Library/Photograph Collection.)

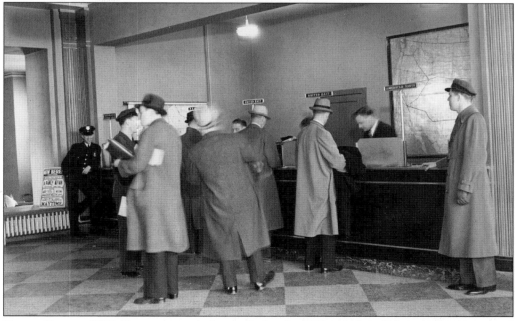

TICKET OFFICE, 1937. Customers wait for service at the airline desks of United, American, and other airlines. The ticket office in the Administration Building was a place patronized by people from all over the globe, which continues today at the Cleveland Hopkins International Airport. (Courtesy Cleveland Public Library/Photograph Collection.)

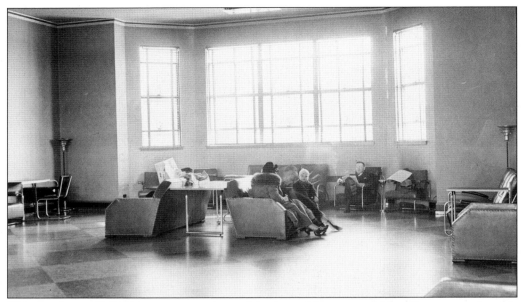

WAITING AREA, 1937. Passengers are pictured in the waiting area, which reflects a comfortable setting indicating that air travel was at an easy pace with the airport being a new hub in the United States. To accommodate the increased number of airline passengers, the terminal was eventually torn down, and a new terminal was constructed in 1956. (Library of Congress.)

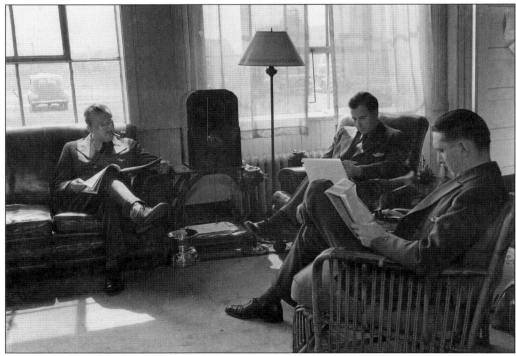

COMFORT LEVEL, 1937. The comfort level is seen with three men sitting and reading in the waiting room with a radio on a table next to a floor lamp and windows. The airport was the first to scheduled interstate passenger service in 1927, which continues today. (Library of Congress.)

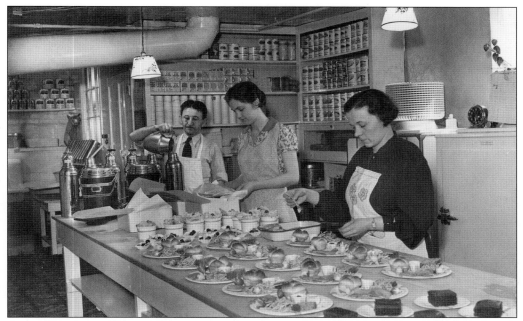

COMMISSARY, 1937. This is a close-up view of two women and a man preparing a table full of meals for airline passengers, including desserts. The shelves were well stocked with canned items. Later, privately owned restaurants also provided extensive snacks and meals. (Courtesy of Cleveland Public Library/Photograph Collection.)

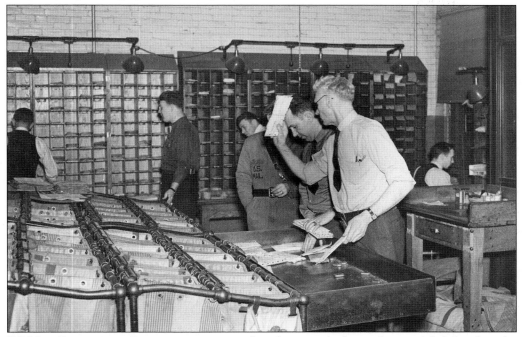

US MAIL ROOM, 1937. Seven men are pictured working inside the mail room. Mail slots line the back wall. The US Postal Service had a major presence at the airport with one of the busiest airmail routes in the United States. (Courtesy of Cleveland Public Library/Photograph Collection.)

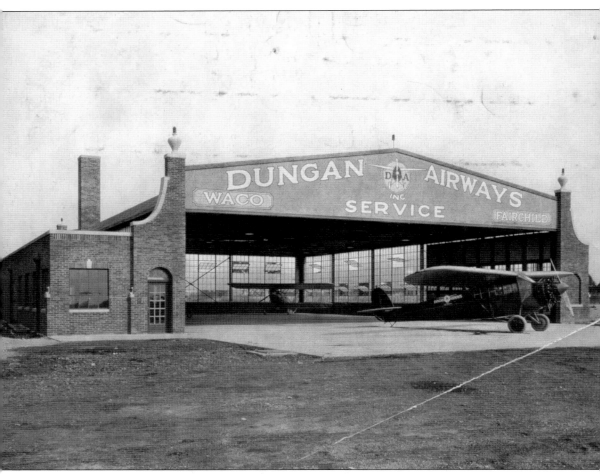

AIRCRAFT HANGAR, 1929. Here is a closer look at one of the aircraft hangars that lined the grounds of the airport in its earliest years. Dungan Airways Hangar was one of many along Hangar Row that included American and United Airlines. Dungan Airways provided student license instruction at the Cleveland Municipal Airport for pilots seeking a commercial license. The WACO sign on the hangar is in reference to the Waco Aircraft Company, an aircraft manufacturer located in Troy, Ohio, from 1920 to 1947, which produced closed-cabin biplane models and open cockpit biplanes. The Fairchild sign was in reference to the Fairchild Aircraft Manufacturing Company, located in Longueil, Canada, from 1920 to 1950, which designed planes for aerial photography. The company was hired by the US government to do aerial photograph surveys of the United States to track soil erosion and its effects. (Library of Congress.)

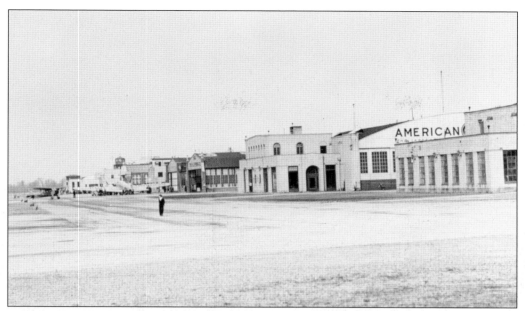

VIEW OF HANGAR ROW, 1937. Pictured is Hangar Row for airmail planes and private contractors that included Ford Motor Company, American Airlines, Thompson Aeronautical Corporation, Stewart Airport Company, and the Ohio National Guard. In 1929, Universal Airlines became a part of the New York Central air-rail transcontinental route. (Library of Congress.)

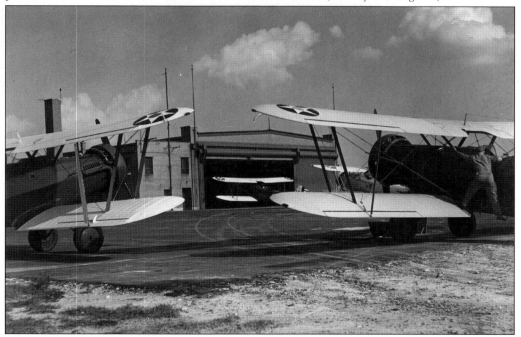

OHIO NATIONAL GUARD HANGAR, 1937. This is a close-up view of four planes pointing toward the open hangar and a man standing on the wing of one plane doing maintenance work. The Ohio National Guard hangar was home to the 112th Observation Squadron. (Courtesy of Cleveland Public Library/Photograph Collection.)

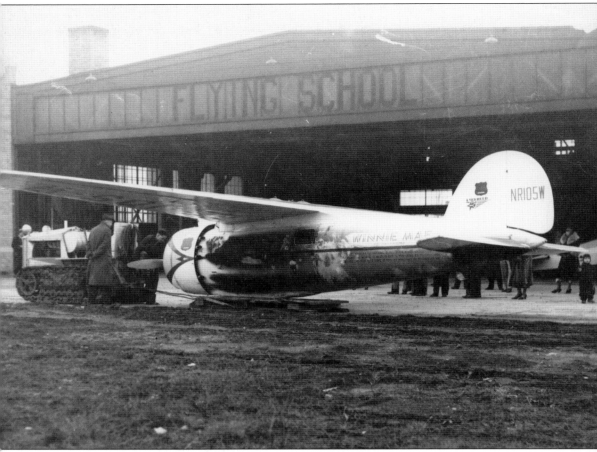

WILEY POST'S PLANE, 1935. This is a ground-level view of the "Winnie Mae" in foreground, with "Flying School" hangar in background. Post was attempting a high altitude nonstop transcontinental flight from California to New York. In 1933, Wiley Post became the first to fly solo around the world and set a record for speed when he landed his Lockheed Vega Winnie Mae at Floyd Bennett Field, Long Island, New York on July 22, 1933, where he started seven days, 18 hours, 49 minutes, 20 seconds earlier. In 1935, he wore the world's first pressure suit, which he assisted in designing and flew a Lockheed 5C Vega into the atmosphere, reaching 340 miles per hour. On August 15, 1935, Post and American Humorist Will Rogers lose their lives when Post's aircraft crashed on takeoff from a lagoon near Point Barrow in the Territory of Alaska. (Courtesy of Cleveland Public Library/Photograph Collection.)

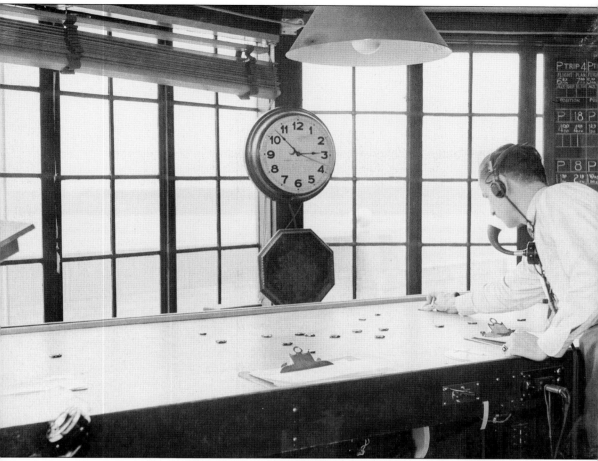

AIR TRAFFIC CONTROL TOWER, 1937. This photograph shows a glass-enclosed control tower with 360 degrees view of incoming and outgoing planes and a view of the ground operations of the airport with employees tracking the flights of the airport. This was the first control tower in the country and was different than the popular low-profile buildings for airports. The use of two-way radio communication slowly became a model for air traffic control across the country. The control tower also directed weather reports through the US Department of Agriculture Weather Bureau Airport Station. The Cleveland airport was one of the first in the United States that received assistance from the weather bureau with forecasts and warnings to airport management and pilots ensuring that there would not be any undue flying risks when it came to inclement weather. (Courtesy of Cleveland Public Library/Photograph Collection.)

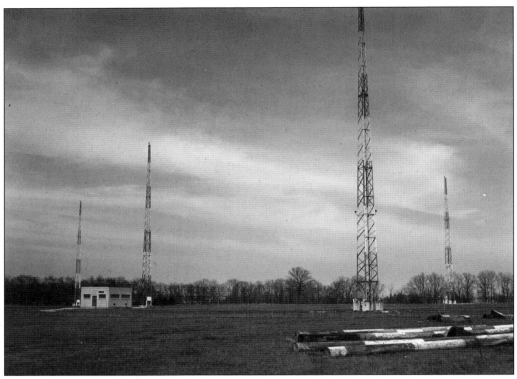

AIRPORT RADIO BEAM STATION, 1937. This is a ground-level view of four tall four-leg radio beam towers in a field. Although located a mile west of the airport, this radio beam station was a major step forward in guiding the planes at night. (Courtesy of Cleveland Public Library/Photograph Collection.)

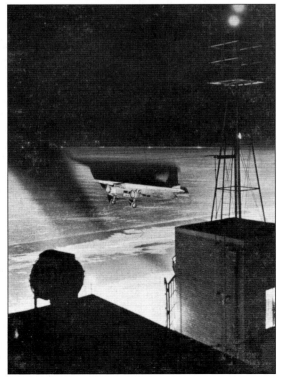

AIR PLANE AT NIGHT, 1931. This is a night view of an aircraft on the tarmac, with buildings in foreground. This was an example of the progression of the airport from its inception in 1925 with the creation of a field lighting system that included boundary lights. (Courtesy of Cleveland Public Library/Photograph Collection.)

AIRPORT FIELD LIGHTING, 1937. Cleveland Municipal Airport was one of a few airports that had nighttime lighting. Airmail service took advantage of the lighting by delivering mail to such cities as Chicago and New York. In the beginning, the lighting tower at the airport consisted of both rotating beacons and fixed course lights. The early lighting was provided by an incandescent oil vapor lamp using pressurized kerosene mantle that had to be manually maintained complimentary to the light tower was the Radio Beam Station. Spectators from the greater Cleveland area would come to the airport to view the nighttime flights. The airport cafeteria provided snacks and meals for passengers and spectators. The airport was a festive scene during the holidays, and people from the greater Cleveland area would come to view incoming and outgoing flights during the day and evening. (Library of Congress.)

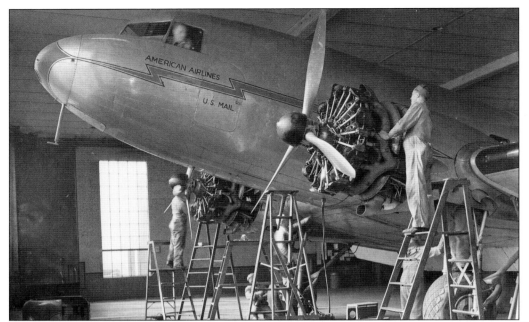

AIRPORT PLANE INSPECTION, 1937. Here is a close-up interior view of the front portion of an American Airlines US Mail plane with six mechanics working on various parts and a man in cockpit window. American Airlines had a major presence at the airport. (Courtesy of Cleveland Public Library/Photograph Collection.)

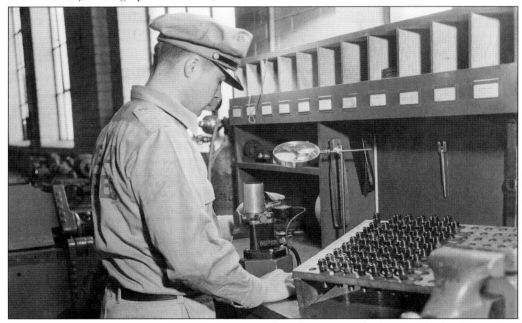

AIRPORT SPARK PLUG SHOP, 1937. A man is pictured working on spark plugs inside the shop. A tray of spark plugs sits next to him in the Spark Plug Overhaul Shop where the plugs were provided to mechanics for airplane maintenance and repairs. (Courtesy of Cleveland Public Library/Photograph Collection.)

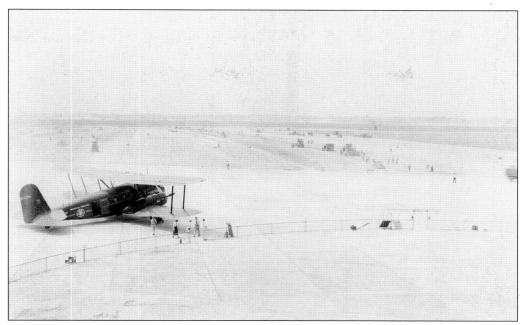

AIRPORT PAVING, 1937. This photograph shows the start of airport paving. Limited funds allowed only partial paving and then in 1936, the Public Works Administration (PWA) of President Roosevelt's Second New Deal started the enlargement of and renovation of airports across the country. (Library of Congress.)

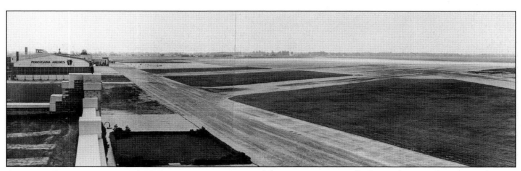

AIRPORT RUNWAY, 1937. This is a panoramic view of the airport grounds from above. The Pennsylvania Airlines hangar is on the left of the photograph, while the airfield comprises a paved runway for the remainder of the photograph which was a needed improvement. (Courtesy of Cleveland Public Library/Photograph Collection.)

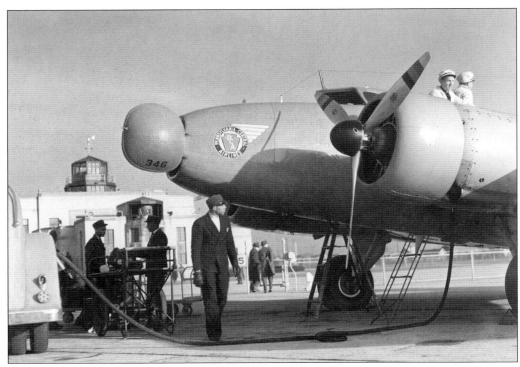

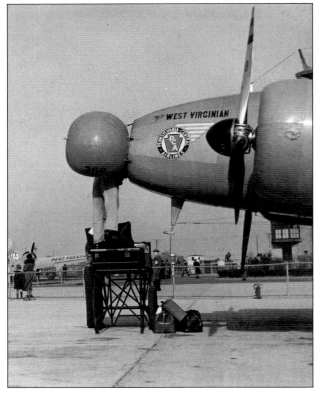

FILLING UP WITH GAS, 1937. The front section of a Pennsylvania Central Airlines Plane is pictured here, with two men on top of the plane and three more beneath it, as it fills up with gas before luggage is loaded. The airport maintenance crews maintained and fueled the planes on a daily basis. (Courtesy of Cleveland Public Library/Photograph Collection.)

STORING LUGGAGE, 1937. Here, the "West Virginian" Pennsylvania Central Airlines plane has been filled with gas, so two men begin to store the luggage inside. Planes and passengers are seen on the other side of the fence in the background of the photograph. (Courtesy of Cleveland Public Library/Photograph Collection.)

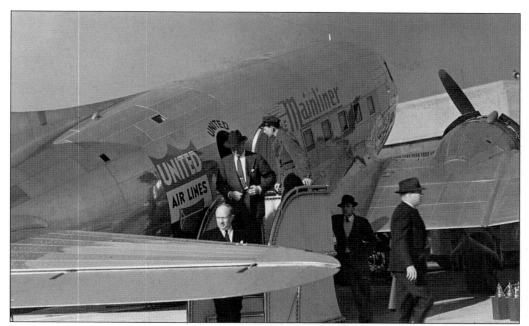

UNITED AIRLINES MAINLINER PLANE, 1937. This a close-up view of a United Airlines Mainliner passenger plane. The Mainliner was known for serving meals. Also shown are five men exiting and standing near the Mainliner, with a portion of the Cleveland Municipal Airport visible in background. (Courtesy of Cleveland Public Library/Photograph Collection.)

UNITED AIRLINES MAINLINER DEPARTURE, 1937. A United Airlines plane is pictured departing the airport. United started flying transcontinental flights in the 1930s and advertised as the nations fasted and most powerful airline with comfort and a timely schedule being the No. 1 priority. (Courtesy of Cleveland Public Library/Photograph Collection.)

US Mail Plane, 1937. Here is a close-up ground-level view of the nose of an American Airlines US Mail plane, with two propellers and one wheel. In the background are airport buildings with hangar areas dedicated to the mail delivery service at the Cleveland Municipal Airport. (Courtesy of Cleveland Public Library/Photograph Collection.)

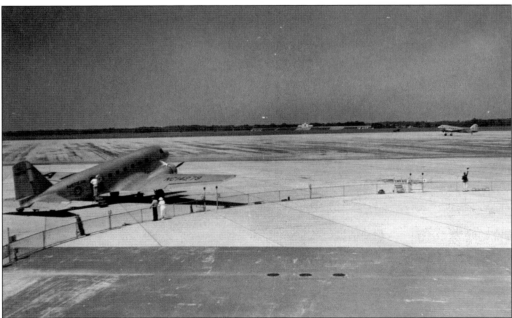

American Airlines Plane, 1937. This is an elevated view of American Airlines plane NC14279, as well as another plane in the distance. The image was taken from the Cleveland Municipal Airport's Administration Building, 1.5 miles across the flying field. (Courtesy of Cleveland Public Library/Photograph Collection.)

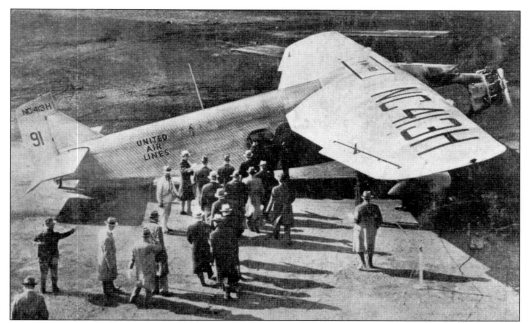

PASSENGER PLANE, 1931. Passengers are pictured here boarding United Airlines plane NC413H. It is noted that the passengers did not have a covered waiting area close to the plane and had to walk outside during nice and inclement weather. (Courtesy of Cleveland Public Library/ Photograph Collection.)

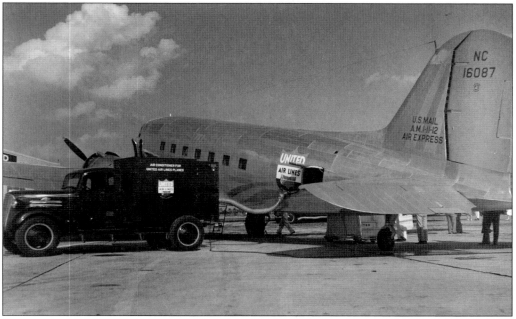

UNITED AIRLINES US MAIL PLANE, 1937. The photograph shows a United Airlines US Mail plane being air-conditioned by a truck with a connecting hose. Temperature fluctuations were a problem with flying in the 1930s, and it took several decades to develop a suitable air-conditioning system. (Courtesy of Cleveland Public Library/Photograph Collection.)

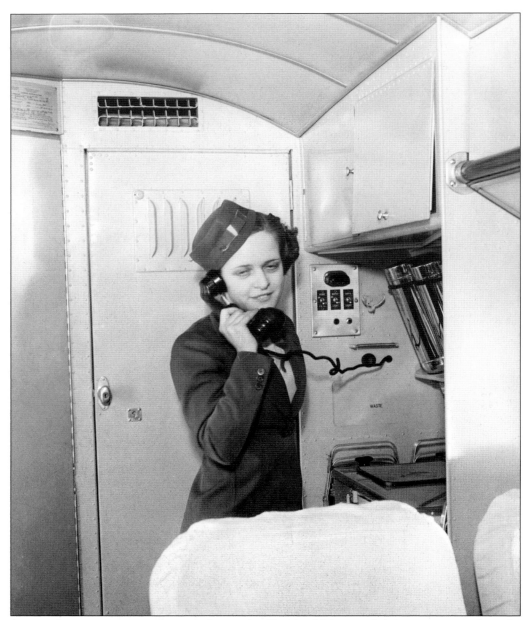

AIRLINE STEWARDESS, 1937. A stewardess at the Cleveland Municipal Airport is pictured on the phone while the plane is at the airport. By 1937, there were between 200 and 300 stewardesses in airline service with the average tenure being between two to three years because of age and marriage restrictions. Often, when a plane was grounded, the stewardess used the railroad table to find the stranded passengers a connecting train to complete their journey. Their duties included cleaning the cabin, dusting, ensuring the seats were secure, restrain passengers from tossing garbage out the windows, and, once in a while, assisted in fueling the plane. In the 1940s, uniforms became fashion statements and more elegant, meaning the stewardesses appeared less like simple worker bees. It took until 1968 before the federal courts struck down the rules forbidding marriage and age requirements. (Courtesy of the Cleveland Public Library/Photograph Collection.)

CLEVELAND PROGRAM COVER, 1929. The 10-day National Air Races featured cross-country races, short races, stunt flying, parachute jumping, balloons, blimp rides, military demonstrations, and model planes. The event promoted air travel and advancing aircraft research and development. People from the greater Cleveland area and the Midwest were among the thousands who attended the races. (Courtesy of Poster-Rama.)

NATIONAL AIR RACES, 1929. Dr. Hugo Eckener (left) and Cleveland city manager W.R. Hopkins (right) are pictured watching the first Cleveland Municipal Airport National Air Races on Labor Day 1929. Dr. Eckener was the commander of the *Graf Zeppelin*, and later, the airport was renamed Cleveland Hopkins International Airport in recognition of W.R. Hopkins's work to establish the first municipal airport in the United States. (Courtesy of Cleveland Public Library/Photograph Collection.)

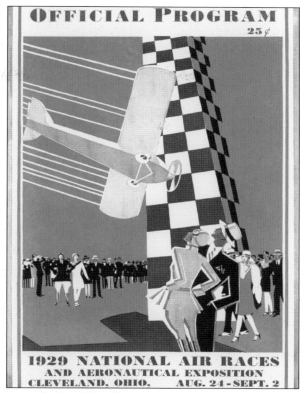

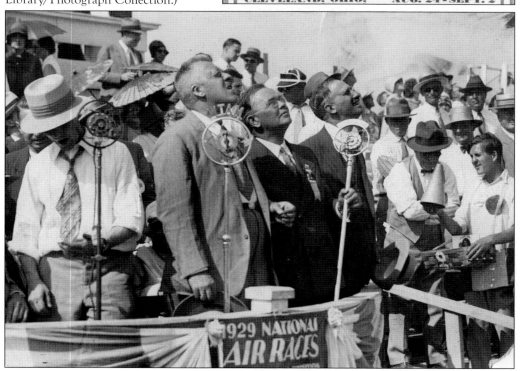

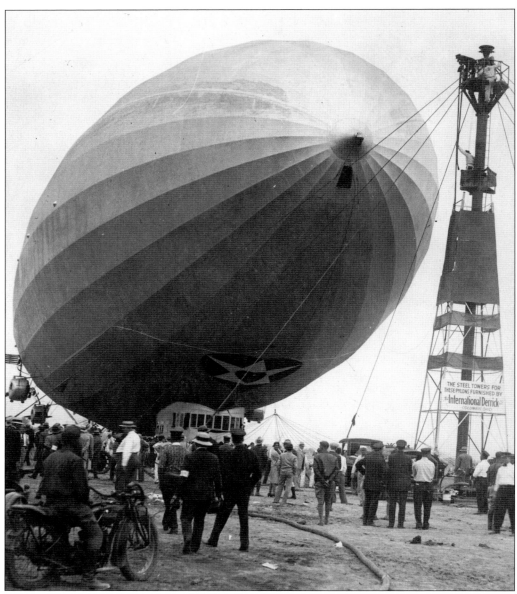

NAVY AIRSHIP, 1929. This is a ground-level view of the US Navy airship *Los Angeles*. The International Derrick steel tower is located to the right of the navy ship, which is tethered to it. Spectators surround the airship in the lower portion of the photograph. The airship was built in 1924 by the Zeppelin company in Friedrichshafen, Germany, as World War I reparations and was designed under agreement limiting the ship for civilian use and was built with a passenger cabin featuring a sleeping accommodation and a galley that could serve hot meals. The Navy operated the *Los Angeles* as a training ship for other airships and attended such events as the Cleveland National Air Races. The airship's maximum speed was 79 miles per hour and had a crew of 10 officers and 33 men. (Courtesy of Cleveland Public Library/Photograph Collection.)

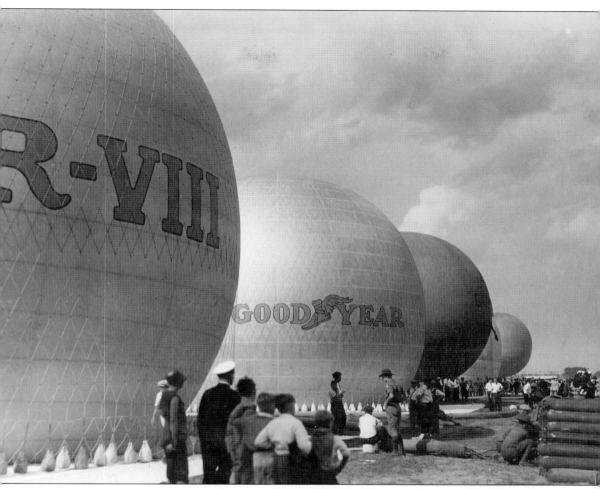

BALLOONS AT THE AIRPORT, 1930. This photograph shows five gas balloons tethered to the ground with nets and weighted bags. Crew and spectators are visible in the foreground and to the right side of the photograph. The crew were preparing the balloons with gas tanks piled neatly and spectators were waiting for the inflation of the hot-air balloons. The spectators wanted to see the one-of-a-kind balloon race that was coming to the Cleveland Municipal Airport on August 31, 1930. A rain storm, accompanied by high winds, canceled the race, and it was rescheduled for Labor Day. The hot-air balloons were to participate in the Gordon Bennett International Balloon Race that had become a tradition at the Cleveland National Air Races, which hosted the world's oldest gas balloon race and was the ultimate in balloon racing. (Courtesy of Cleveland Public Library/ Photograph Collection.)

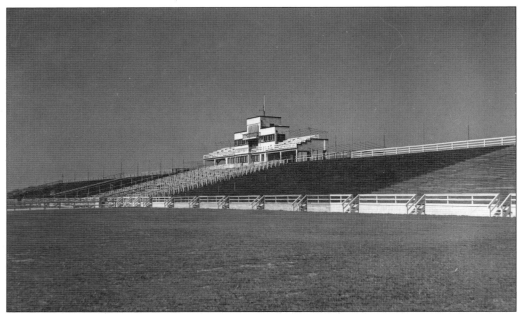

NATIONAL AIR RACES GRANDSTAND, 1937. This is a ground-level view of an empty grandstand. The seating capacity of reserved and unreserved sections was 60,000 with spectators brought to the air races by streetcars. The reserved section was popular since the spectators had easy access to refreshments. (Courtesy of Cleveland Public Library/Photograph Collection.)

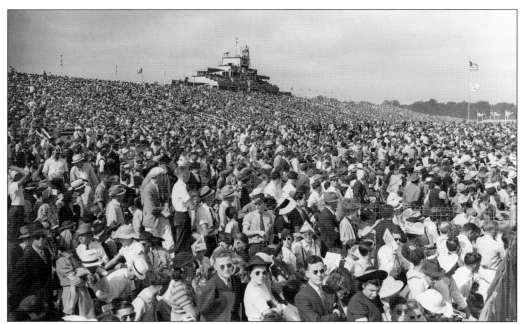

NATIONAL AIR RACES GRANDSTAND, 1938. Here, the crowd got to witness many race records broken. The Thompson Trophy race had been lengthened to 30 laps of a 10-mile circuit, and on September 5, 1938, Roscoe Turner won the race with an average speed of 283.4 miles per hour. (Courtesy of Cleveland Public Library/Photograph Collection.)

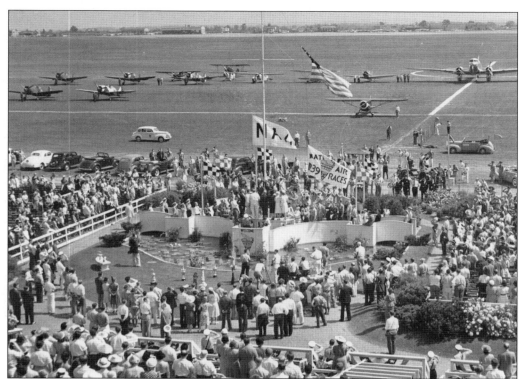

NATIONAL AIR RACES, 1939.
This photograph shows the air races at the Cleveland Municipal Airport. Pylons were set up for cross-country races. The races had their start at Roosevelt Field, Long Island, and then were moved to the Cleveland Municipal Airport in 1929. (Courtesy of Cleveland Public Library/ Photograph Collection.)

NATIONAL AIR RACES, 1948. This mechanical reproduction promotional photograph shows spectators and cars on airport property with two planes in the air. A label is in the top-left corner of the photograph illustration advertising the air races with an airplane in the center. (Courtesy of Cleveland Public Library/ Photograph Collection.)

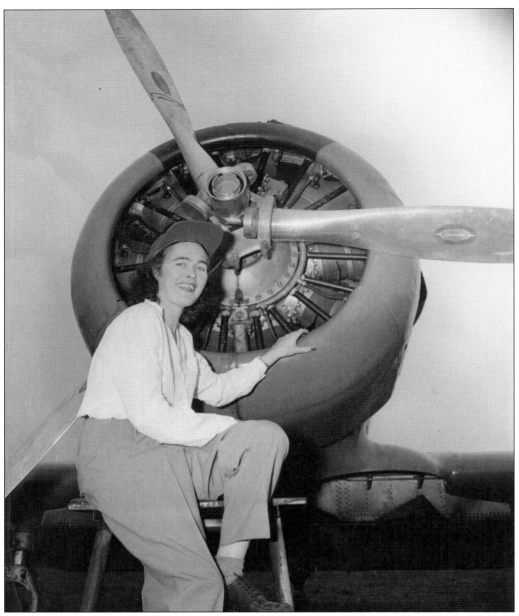

NANCY CORRIGAN, 1948. Pioneer aviator Nancy Corrigan (1913–1983) moved from Ireland to Cleveland in 1929. She made her first solo flight at the age of 19 after less than five hours of flight training. Her dreams of flying across the Atlantic Ocean and competing in the National Air Races were sidetracked, as she first became a famous model in New York, working for the John Robert Powers modeling agency. With money earned from modeling, she bought her own plane, and became the second woman in the United States to obtain a commercial pilot's license. During World War II, she trained air cadets who would go on to become combat pilots. In 1948, she competed in the National Air Race Kendall Trophy event in Cleveland, flying an AT-6 military trainer and finishing fifth. As a commercial pilot, she logged 600,000 flight miles, before retiring in the 1960s. (Courtesy of Cleveland Public Library/Photograph Collection.)

Three

CLEVELAND BOMBER PLANT

Located in the village of Brook Park, the International Exposition Center was built in 1942 by the US War Department during World War II and was originally known as the Cleveland Aircraft Assembly Plant No. 7. Brook Park was chosen because of the Midwest location, and some say it was constructed there because of possible enemy attacks on the East and West Coasts.

The Assembly Plant was eventually operated by General Motors Corporation and was called the Fisher Body Aircraft Plant No. 2 but was commonly known as the Bomber Plant. It manufactured component parts for the B-29 Superfortress bomber. This site was located at 6300 Riverside Drive in Brook Park, which was the beginning of industrial expansion in the greater Cleveland, Ohio, area, especially in Brook Park, and was the home to more than 15,000 workers at the plant. The 2,270,000 square feet facility on 411.5 acres later became home to the Cleveland Tank Plant during the Korean and Vietnam Wars.

New housing and apartment complexes were built on nearby Trickett and Berea Roads, and workers were transported by Cleveland Transit System (CTS) bus, which was called the Bomber Bus, where the US Housing Authority constructed homes to accommodate the plant employees. Late in 1944, consideration was given to producing the XP-75, which was a long-distance fighter, but only a few were manufactured because of mechanical problems.

It was evident that Brook Park was the hub of aviation manufacturing and technology, boosting the local economy during World War II and a transportation center by air and rail with spurs of the New York Central Railroad at the aircraft assembly plant that assisted in moving aircraft parts to the various assembly sites across the country. This chapter includes photographs of the manufacturing of the B-29 Superfortress component parts to the present-day usage as the I-X Center.

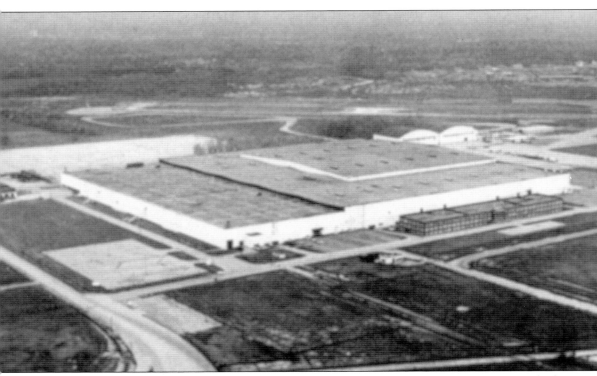

AIRCRAFT ASSEMBLY PLANT NO. 7, 1942. This photograph shows administrative offices attached to the front of the Cleveland Aircraft Assembly Plant No.7. The building was 148,130 square feet with a basement and two floors. The basement was 49,275 square feet with a ceiling height of 9 feet, 7 inches; first floor was 49,275 square feet with a ceiling height 9 feet, 7 inches; and the second floor was 49,580 square feet with a ceiling height of 10 feet, 4 inches. The photograph also shows the main Assembly Building of the Aircraft Assembly Plant No. 7 that was on 411.5 acres. The building had cafeteria seating for 4,000 people, sanitary facilities for 7,000 employees and lockers for 10,000 men and 8,000 women. The main building was 2,270,000 square feet, basement was 597,000 square feet, first floor was 1,258,000 square feet, and second floor was 415,000 square feet. After the plant closed in 1945, it was later converted into the Cleveland Tank Plant in 1950, which closed in 1972. (Courtesy of Cleveland Memory Project.)

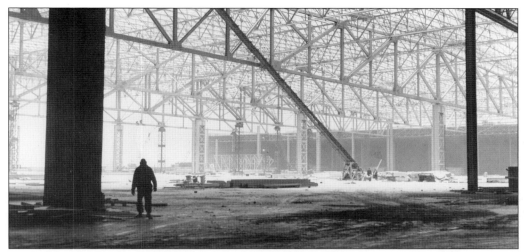

AIRCRAFT ASSEMBLY PLANT, 1943. This photograph shows the expansion of the plant under the supervision of the Fisher Body Division of the General Motors Corporation. The building of the steel-framed section of the aircraft assembly plant was under the supervision of the Detroit District of the US Army Corps of Engineers. (Courtesy of US Army Corps of Engineers.)

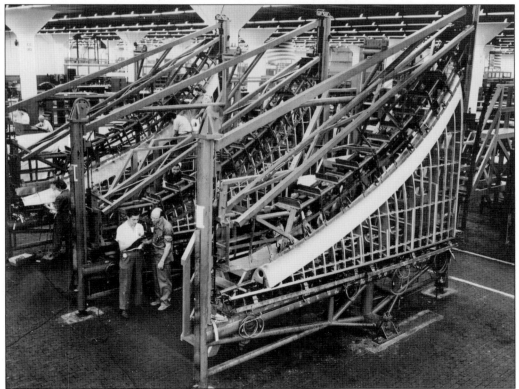

DORSAL FIN ASSEMBLY JIGS, 1944. Pictured here is a row of dorsal fin assembly jigs at Brook Park's Fisher Body Aircraft Plant No. 2 for the B-29 Superfortress bomber during World War II. The dorsal fin was needed to add directional stability to the aircraft. (Courtesy of Cleveland Public Library/Photograph Collection.)

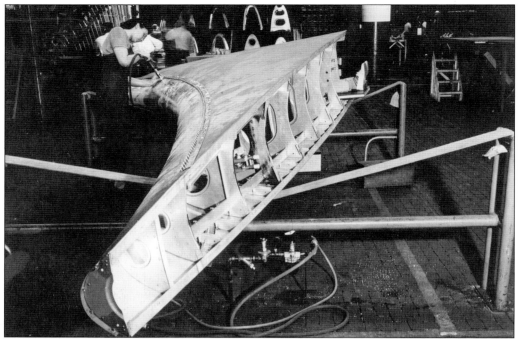

DORSAL FIN ASSEMBLY, 1944. Pictured is a dorsal fin that added directional stability to the B-29 Superfortress bomber at the Fisher Body Aircraft Plant No. 2. The Army Air Forces manufacturing component parts was the major focus at the plant since they were shipped to assembly plants. (Courtesy of Cleveland Public Library/Photograph Collection.)

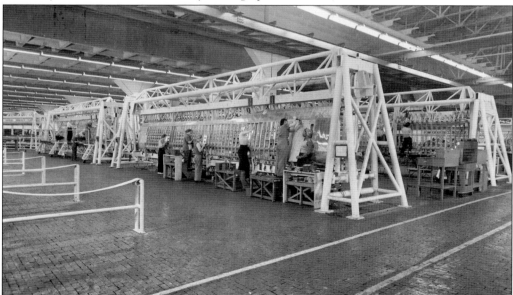

ASSEMBLING WING FLAPS, 1944. Women workers are pictured assembling wing flaps for the B-29 Superfortress bomber, the Army Air Forces new Superfortress at the Fisher Body Aircraft Plant No. 2. The photograph shows the giant fixtures on which wing flaps are mounted. (Courtesy of Cleveland Public Library/Photograph Collection.)

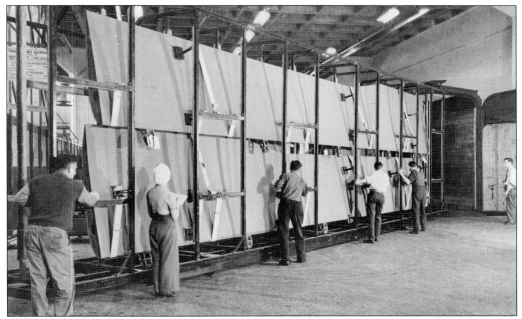

COMPLETED WING FLAPS, 1944. Workers at the Fisher Body Aircraft Plant No. 2 are pictured moving completed wing flaps, whose purpose was to divert the air around the wing. The flaps were designed for the B-29 Superfortress bomber, which were readied for shipment. (Courtesy of Cleveland Public Library/Photograph Collection.)

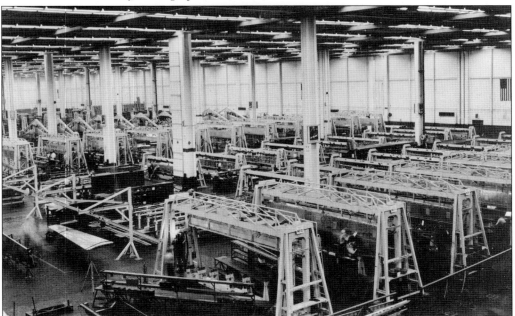

OUTBOARD WING ASSEMBLY JIGS, 1944. This photograph shows the B-29 Superfortress bomber outboard wing assembly jigs at the Fisher Body Aircraft Plant No. 2. The jig was used to provide repeatability, accuracy, and interchangeability in the manufacturing of the outboard wing components of the B-29 bomber. (Courtesy of Cleveland Public Library/Photograph Collection.)

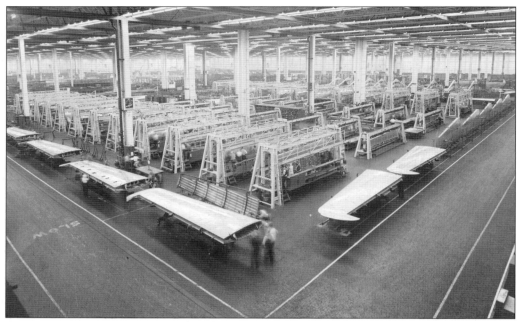

OUTBOARD WING ASSEMBLY, 1944. This photograph shows the final assembly for the B-29 Superfortress bomber outboard wings at the Fisher Body Aircraft Plant No. 2. Note the forest of jigs and fixtures facilitating the assembly of wings in a large area of the assembly plant. (Courtesy of Cleveland Public Library/Photograph Collection.)

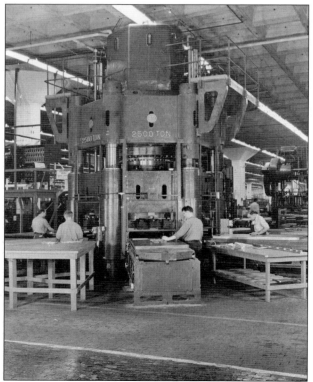

HYDRO-PRESS, 1944. A 2,500-ton hydro-press is pictured at the Fisher Body Aircraft Plant No. 2. It was used to stamp out parts for Boeings B-29 Superfortress bomber where the press punches out parts simultaneous, which was done on a mass production basis at the plant. (Courtesy of Cleveland Public Library/Photograph Collection.)

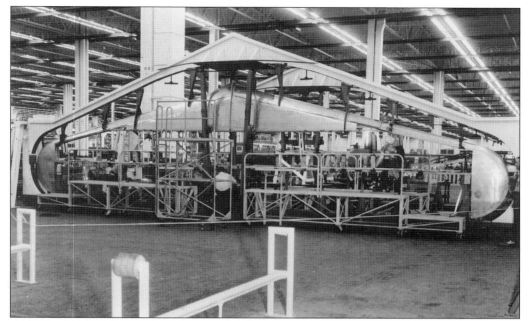

STABILIZER JIGS, 1944. Pictured here are stabilizer jigs in which workmen assemble stabilizers at the Fisher Body's Cleveland Aircraft Plant No. 2. The plant was a major producer of stabilizers for assembling of the B-29 Superfortress bomber component parts at plants across the country. (Courtesy of Cleveland Public Library/Photograph Collection.)

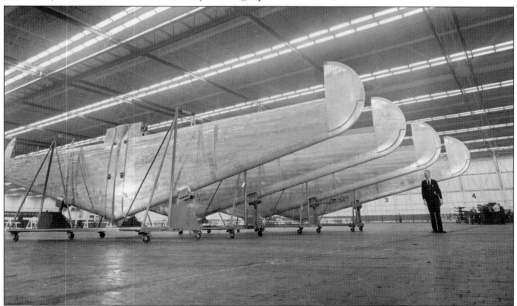

COMPLETED STABILIZERS, 1944. This photograph shows completed stabilizers for the Army Air Forces new B-29 Superfortress bomber in a section of the Fisher Body Aircraft Plant No. 2 where the hydro-press has stamped out parts for the stabilizer. At that time, the plant, through mass production, had reached volume output of B-29 Superfortress bomber component parts and assemblies. (Courtesy of Cleveland Public Library/Photograph Collection.)

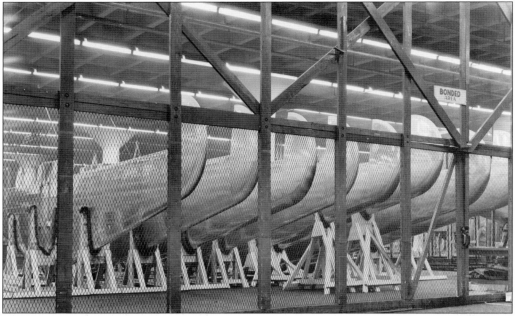

STORAGE OF HORIZONTAL STABILIZERS, 1944. This photograph shows completed horizontal stabilizers for the B-29 Superfortress that were stored for shipping in a government-bonded area at the Fischer Body Aircraft Plant No. 2. Fisher was a volume producer for major parts and assemblies for the long-range bomber. (Courtesy of Cleveland Public Library/Photograph Collection.)

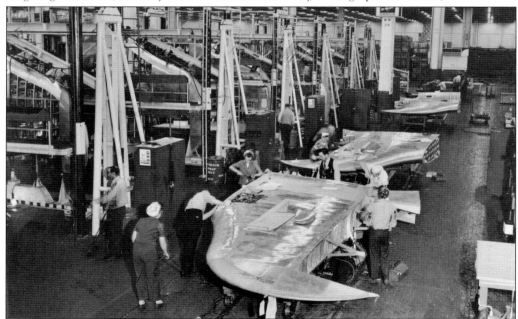

VERTICAL FIN, 1944. Female employees are pictured working on the vertical fin at the Fisher Body Aircraft Plant No. 2 for the B-29 Superfortress bomber the Army Air Force's new Superfortress. The vertical fin stabilizes the aircraft during flight, especially when there were high winds. (Courtesy of Cleveland Public Library/Photograph Collection.)

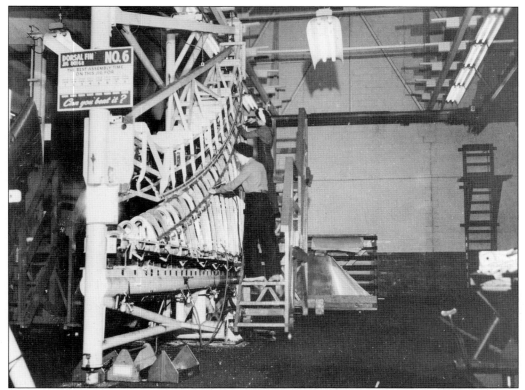

WORKERS MAKING A DIFFERENCE, 1944. Women played an important role at the plant in the drive to out-produce the Axis powers. Two black-attired workers at the Fisher Body Aircraft Plant No. 2 are helping to assemble a dorsal fin for the B-29 Superfortress long-range bomber. (Courtesy of Cleveland Public Library/Photograph Collection.)

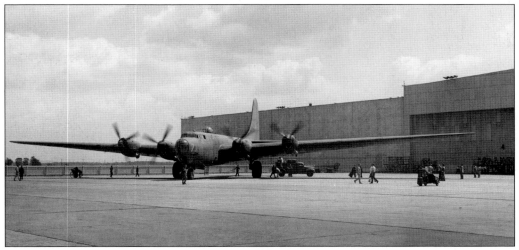

B-29 BOMBER, 1944. This photograph, taken at the Cleveland Municipal Airport, shows the largest bomber in the world at that time, the Army Air Forces B-29 Superfortress. Through trials, it was fitted with new, more powerful engines by the Fisher Body Division of General Motors. (Courtesy of Cleveland Public Library/Photograph Collection.)

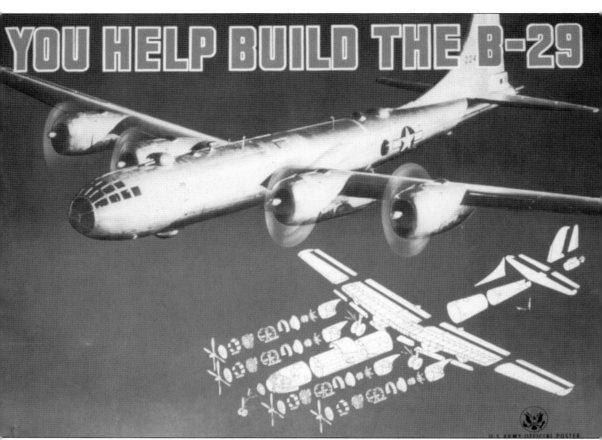

B-29 SUPERFORTRESS BOMBER COMPONENTS, 1943–1945. This photograph shows wings, horizontal stabilizers, vertical stabilizer, and flaps that were manufactured in the Assembly Hall of the plant. Most of the plant floor was used to assemble the stabilizers into a final product. The horizontal stabilizer is the fixed wing section of the plane that provided stability to the plane and prevents up-and-down motion of the nose or pitch while the vertical stabilizer keeps the nose of the plane from swinging from side to side. The flaps divert the air around the wing and are used to increase lift for takeoff or increase drag for landing. The Fischer Body Aircraft Plant No. 2 was responsible for providing these main structural parts for over 2,600 B-29s during World War II. (Courtesy of NASA Glenn Research Center.)

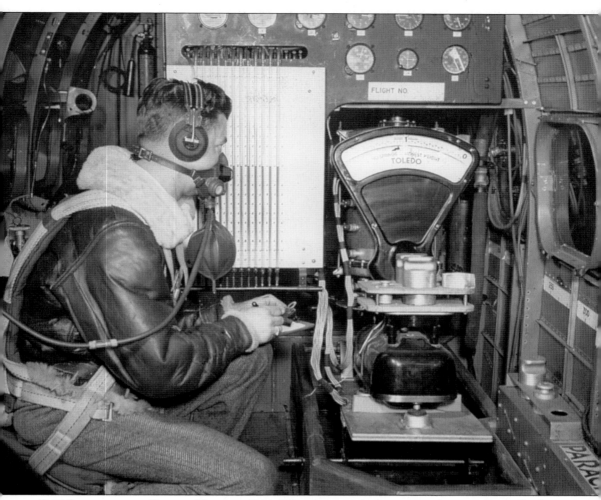

B-29 SUPERFORTRESS BOMBER TESTING, 1944. This photograph documents the recording of high-altitude flight data in a flying laboratory at the Aircraft Engine Research Laboratory of the National Advisory Committee for Aeronautics, now known as the NASA Glenn Research Center at Lewis Field. The aircraft is a modified B-29 bomber, manufactured by Boeing; it was the backbone of the World War II effort. It was used to determine what conditions cause ice to form on wings and aircraft surfaces in the flying laboratory. The testing was an extension of the Fisher Body Aircraft Plant No. 2 work during World War II where NACA, in conjunction with the plant and the Cleveland Municipal, ran tests on Boeing's B-29 Superfortress that led to solving the engine overheating problem of the giant aircraft during World War II. (Courtesy of NASA Glenn Research Center.)

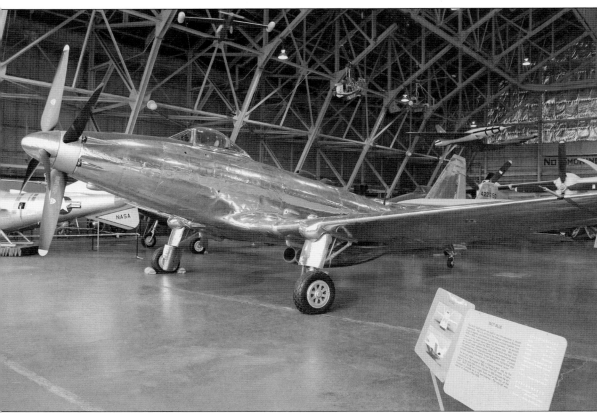

WORLD WAR II XP-75 EAGLE, 2013. Pictured is one of the aircraft that was built at the Fisher Body Aircraft Plant No. 2, with eight XP-75s and six XPAs built at the plant during the war to fill an urgent need for an interceptor early in World War II. The production of the aircraft encountered problems, such as it was too big and had a low-powered engine that led to the plane's sluggish maneuverability and handling, which in essence made it virtually useless as a fighter plane where fight tests in late 1943 revealed unsatisfactory performance of the first two XP-75 prototypes. The XP-75 program was canceled by the US Army in October 1944, which put an end to the manufacturing of the Eagle program that was to create long-range fighter planes to escort bombers into enemy territories. (Courtesy of David Jackson.)

ASSEMBLY PLANT CAFETERIA AREA, 2017. This photograph shows the expansive cafeteria area that was in the basement of the Cleveland Aircraft Assembly (Fisher Body Aircraft Plant No. 2) and Cleveland Tank Plant from World War II until early 1972. The original cafeteria had a seating capacity for 4,200 workers. (Courtesy of David Jackson.)

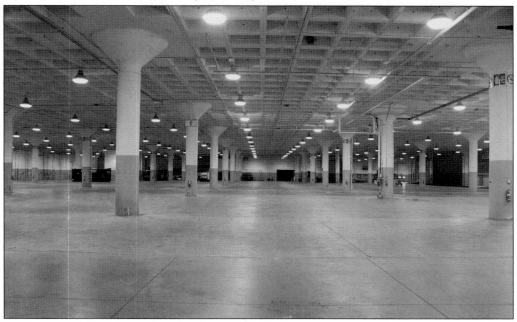

MAIN ASSEMBLY SECTION, 2017. The photograph shows one of two areas that was used to build the B-29 Superfortress bombers wings, horizontal stabilizers, vertical stabilizers, and flaps that were shipped to final assembly plants. It took a massive area to manufacture the basic component parts of the B-29 Superfortress bomber. (Courtesy of David Jackson.)

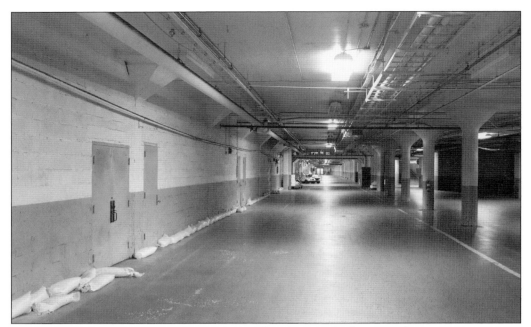

AIRCRAFT ASSEMBLY PLANT CORRIDORS, 2017. The photograph illustrates the immense nature of the 2,270,000-square-foot complex with the corridors designed to make it easy for the employees to move to their work stations. The size of the corridor fits with expansive nature of the Assembly Plant. (Courtesy of David Jackson.)

CLEVELAND HOPKINS INTERNATIONAL AIRPORT, 2017. The photograph shows renovated hangars at the airport that may at one time housed the B-29 Superfortress bombers during World War II since it could accommodate the bomber's wing span of 141 feet and 3 inches. Today, the hangars are maintained by the Cleveland Hopkins International Airport. (Courtesy of David Jackson.)

Four

NASA GLENN RESEARCH CENTER

In 1941, more of the village of Brook Park's open fields were developed with the construction of the Aircraft Engine Research Laboratory, which served as the National Advisory Committee for Aeronautics research laboratory that focused on developing and improving aircraft technology during World War II with the adjacent Cleveland Municipal Airport being the perfect venue to test and create better engines for military aircraft, testing of jet propulsion advancement using wind tunnels, and developing airfoil shapes for wings and propellers.

This new facility, especially with the start of World War II, brought another work force, like the Cleveland Municipal Airport and Cleveland Bomber Plant, to Brook Park and the greater Cleveland area. The US Housing Authority constructed homes for the plant employees since Brook Park had shifted from a rural setting to an urban industrial center that was meeting the war demands.

When NACA opened in 1941, the war in Europe had been raging since September 1939, a little over two years before the United States enter the conflict. After the United States became a part of World War II in December 1941, NACA became a major player in upgrading military aircraft engines for combat with improvements in engine speed and altitude performance during early stages of World War II.

The photographs in this chapter depict the start of a small research center in a farmhouse that led to the Aircraft Engine Research Laboratory playing a major role during World War II by developing an Altitude Wind Tunnel that tested military aircraft with recommendations to the military on how to improve engine performance. Today, the NASA Glenn Research Center at Lewis Field employs more than 3,000 employees who are on the cutting edge of microgravity research.

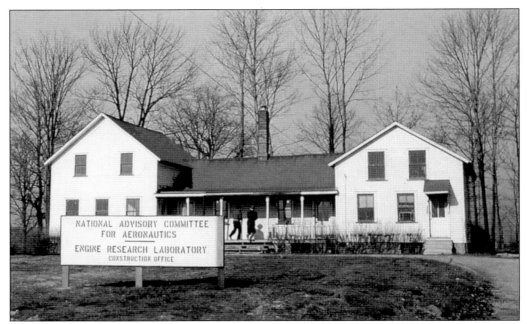

FARMHOUSE OFFICE, 1941. This farmhouse in rural Brook Park, Ohio, served as NACA's main office until the opening in 1942 of the Administration Office, which turned out to be in a converted hangar. In the early 1950s, the farmhouse was relocated behind the new Administration Building. (Courtesy of NASA Glenn Research Center.)

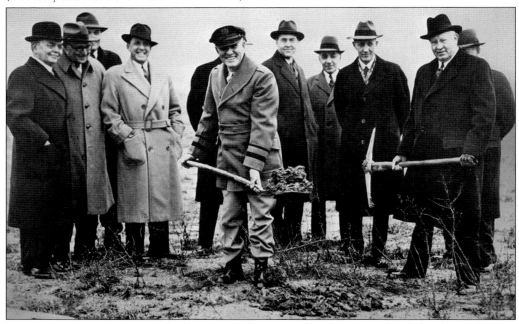

GROUNDBREAKING, 1941. Local politicians and NACA officials were on hand for the January 23, 1941, groundbreaking of NACA's Aircraft Engine Research Laboratory. Over the years, there were many name changes where today the center is called the NASA Glenn Research Center. (Courtesy of NASA Glenn Research Center.)

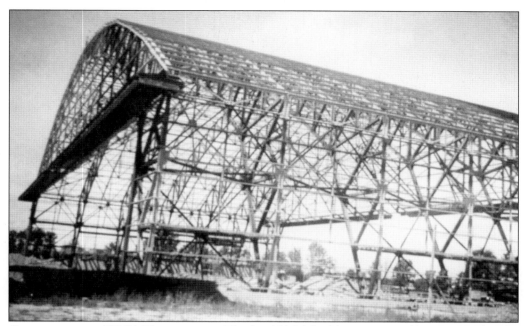

CONSTRUCTION OF NACA HANGAR, 1941. The first NACA building is pictured being erected in the open fields of Brook Park. The 272-by-150-foot hangar had a 90-foot clearance at its highest point. The hangar was needed as a shelter for the growing staff, who occupied the nearby farmhouse. (Courtesy of NASA Glenn Research Center.)

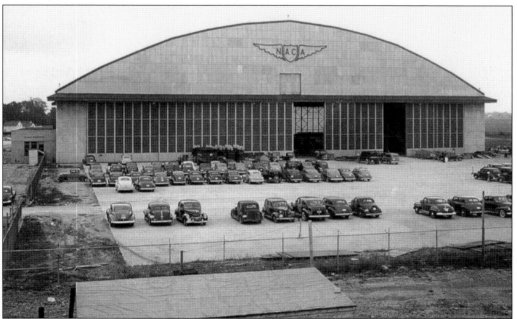

AIRCRAFT ENGINE RESEARCH LABORATORY, 1942. This photograph shows NACA's Flight Research Building, which was used as a temporary office complex to house the staff while other buildings were completed. The hangar offices were used for an entire year before being removed in early 1943. (Courtesy of NASA Glenn Research Center.)

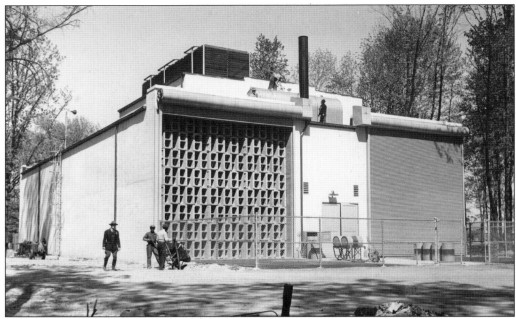

ENGINE AND PROPELLER BUILDING, 1942. This is an exterior view of the National Advisory Committee for Aeronautics Airplane Engine Research Laboratory engine and propeller building during World War II. Three men, including guards, appear outside of the building, with two standing on top of the building. (Courtesy of Cleveland Public Library/Photograph Collection.)

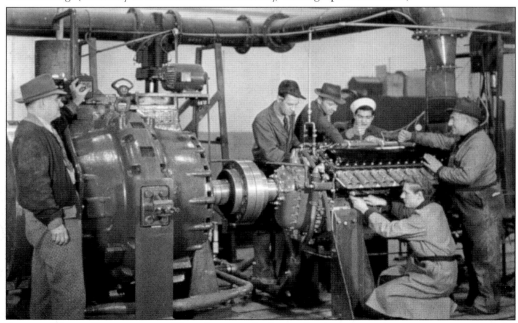

ALLISON V-1710 ENGINE, 1943. This photograph shows the first research assignment created for NACA. The task was the integration of a supercharger into the Allison engine. The military provided three engines to the laboratory research divisions to integrate the supercharger, improve the cooling system, and remedy associated engine knocks. (Courtesy of NASA Glenn Research Center.)

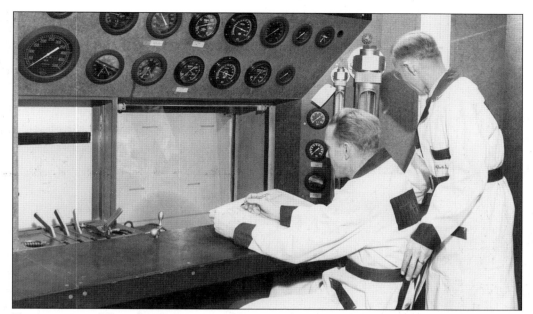

TECHNICIANS AT WORK, 1942. Here is a close-up of the interior view of NACA Airplane Engine Research Laboratory. Two technicians check the gauges on the wall in front of them. During World War II the laboratory was a hub for testing innovative aeronautical technology, which was continued by the NASA Glenn Research Center. (Courtesy of Cleveland Public Library/Photograph Collection.)

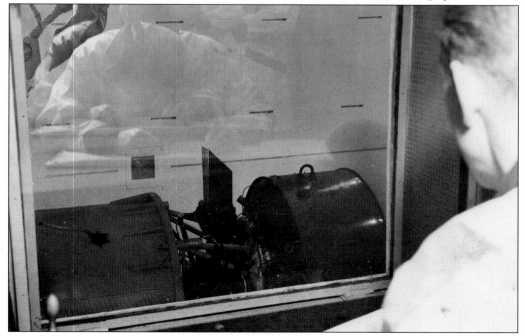

NACA'S TESTING ROOM, 1942. The photograph shows a close-up view of a test engine with reflections on the glass of the two technicians in the control room. At beginning of World War II, military aircraft were encountering engine problems so testing was critical to increasing the engine power of military aircraft. (Courtesy of Cleveland Public Library/Photograph Collection.)

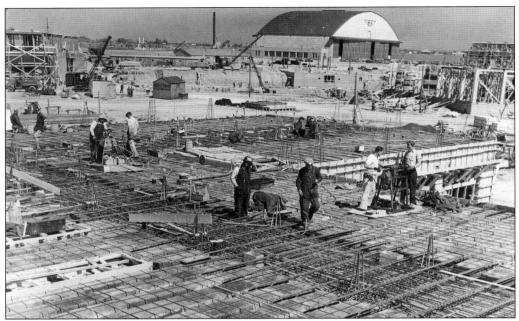

NACA's Lab Expansion, 1942. Construction crews are pictured working on the Fuels and Lubricants Building for NACA. The photograph reemphases the importance of the lab's work that not only dealt with airplane engine improvement but also was key to having the right fuels for operation. (Courtesy of Cleveland Public Library/Photograph Collection.)

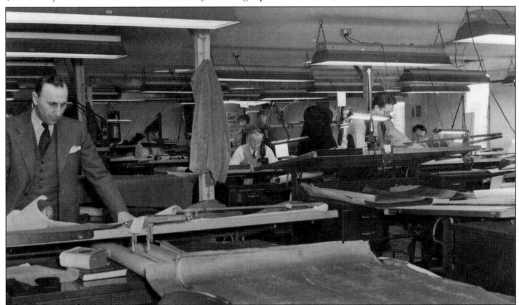

Drafting Work Area, 1942. Men are pictured working at drafting tables inside the temporary mechanical drafting room of the National Advisory Committee for Aeronautics, Aircraft Engine Research Laboratory. Drafting was a major portion of the lab's work as there was a race against time to better mechanize military aircraft to combat the Axis air power in Europe. (Courtesy of Cleveland Public Library/Photograph Collection.)

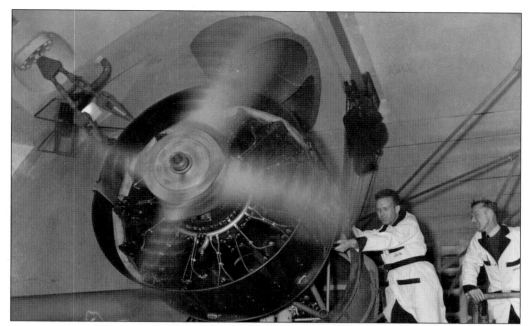

PROPELLER IN MOTION, 1942. This photograph, taken from below, shows a propeller in motion with technicians John L. Gore and Melvin Harrison standing nearby. The propeller appears to be suspended from the ceiling in the NACA research laboratory. (Courtesy of Cleveland Public Library/Photograph Collection.)

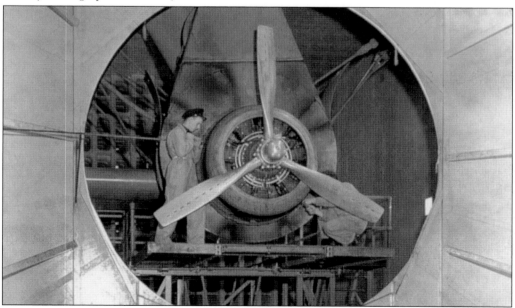

ENGINE PROPELLER RESEARCH, 1943. This World War II–era photograph shows a NACA researcher testing the performance of fuels, turbochargers, water injection, and cooling systems that led to the improved engine performance of the military aircraft serving in the Pacific and Europe during World War II. The facility was also used to investigate a captured German V-1 buzz bomb during the war. (Courtesy of NASA Glenn Research Center.)

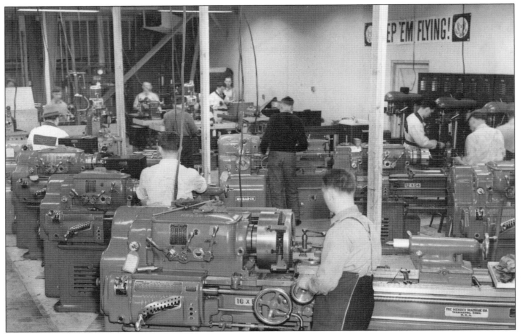

NACA Machine Shop, 1942. The interior of the machine shop is pictured here. The workers were producing parts for airplane engines and other modifications to streamline and modernize military aircraft during World War II. (Courtesy of Cleveland Public Library/Photograph Collection.)

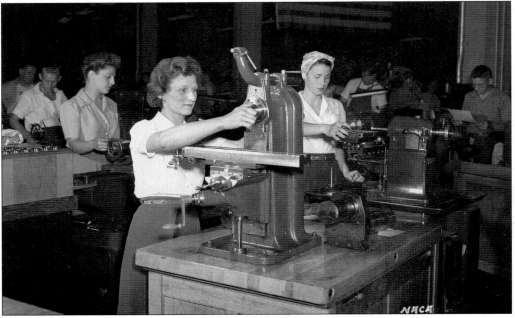

Female Staff at AERL, 1944. This photograph shows women working in the Fabrication Shop of the Aircraft Engine Research Laboratory (AERL) during World War II. The women were recruited to replace male employees serving in the military and were trained as machine operators, electricians, and other technical positions. (Courtesy of NASA Glenn Research Center.)

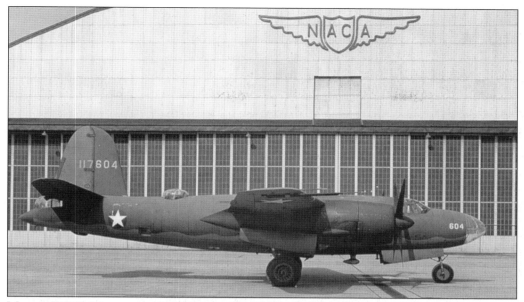

Martin B-28B Marauder, 1943. During World War II, the military wanted NACA to improve the engine in order to increase the bombers' performance. Because of the work to increase the fuel and engine performance, the military lost fewer Marauders than any other type of bomber used in the war. (Courtesy of NASA Glenn Research Center.)

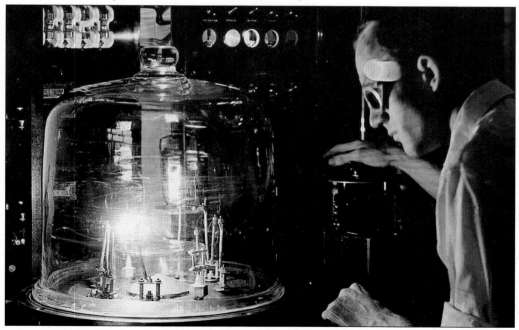

Fuel Laboratory Researcher, 1943. The NACA Aircraft Engine Research Laboratory was asked by the military during World War II to study the fuel ignition process to improve fuels and lubrication with the intent of getting aircraft into the air as quickly as possible. As part of the war effort the lab studied 18 different types of fuel blends, leading to better engine performance. (Courtesy of NASA Glenn Research Center.)

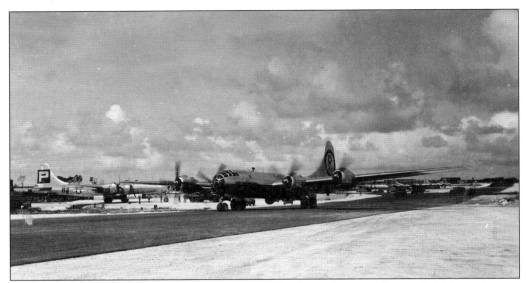

ENOLA GAY, AUGUST 6, 1945. This photograph shows the *Enola Gay*, a Boeing B-29 Superfortress bomber, returning to Tinian, Northern Mariana Islands, after the strike at Hiroshima with the first atomic bomb on August 6, 1945. Piloted by Col. Paul Tibbets Jr., the flight totaled 3,000 miles. The bomber was named after the pilot's mother, Enola Gay Tibbets. (Courtesy of NARA.)

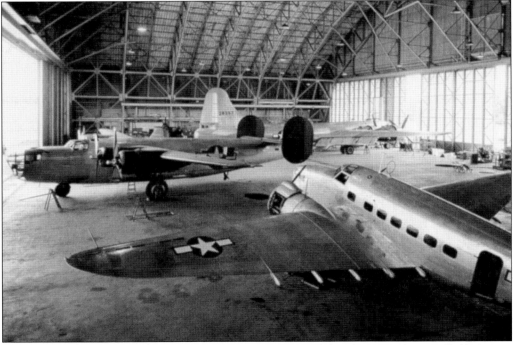

FLIGHT RESEARCH BUILDING, 1944. Pictured here are a consolidated B-240 Liberator (left), Boeing 29 Superfortress (background), and Lockheed RA Hudson (background), which are parked inside the Flight Research Building at the National Advisory Committee for Aeronautics Aircraft Engine Research Laboratory. Other planes in the background were a P-47G Thunderbolt and P-63 King Cobra. (Courtesy of NASA Glenn Research Center.)

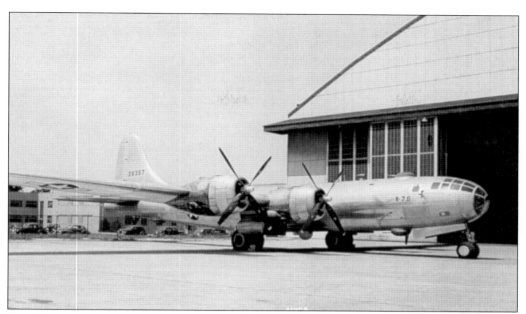

B-29 Superfortress Bomber, 1944. This photograph shows the Cleveland Municipal Airport extension to NACA that allowed for needed modifications to military aircraft. The Superfortress bomber was forced to carry 20,000 pounds, which was more than it was originally designed for, and had engines that overheated, creating problems during flight. (Courtesy of NASA Glenn Research Center.)

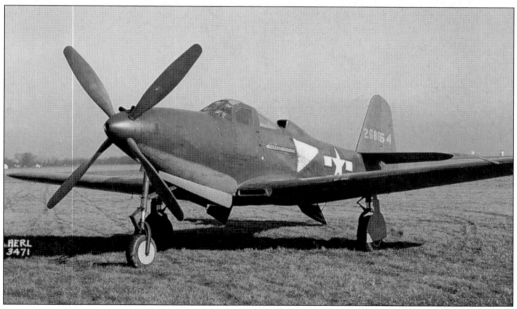

Bell P-63 Kingcobra, 1944. Pictured is the Bell P-63 Kingcobra at the Aircraft Engine Research Laboratory. It was lent by the Army Air Forces during World War II to improve the Allison V-1710 engine. The Kingcobra could reach speeds of 410 miles per hour and an altitude of 43,000 feet, but there were persistent performance problems at high altitudes. (Courtesy of NASA Glenn Research Center.)

ALTITUDE WIND TUNNEL, 1944. Pictured here is the Altitude Wind Tunnel that was used to examine the Boeing B-29 Superfortress bomber engine cooling problems, which was one of the Aircraft Engine Research Laboratory key contributions to the World War II effort. The engines frequently strained and overheated due to large payloads, which resulted in engine fires and crashes. The military asked NACA to work on the overheating issue. The lab used the Altitude Wind Tunnel, which simulated flight conditions at high altitudes, and its use led to reduction of drag and improved the air flow by reshaping the cowling inlet and outlet. This change meant better engine performance of the B-29, and solving the overheating problem became a method of examining other military aircraft brought to the laboratory to fix engine problems. (Courtesy of NASA Glenn Research Center.)

BELL P-39, 1944. The photograph shows the plane during World War II in the NACA Aircraft Engine Research Laboratory's Icing Research Tunnel for a propeller deicing study. NACA investigators found methods of preventing ice-buildup on the P-39's propeller, including the use of internal and external electrical heaters, alcohol, and hot gases, which led to intermitted heating of the propellers. (Courtesy of NASA Glenn Research Center.)

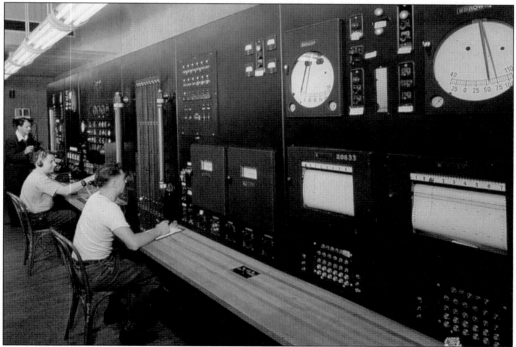

CONTROL ROOM, 1944. Operators are pictured in the control room of the Altitude Wind Tunnel at the National Advisory Committee for Aeronautics Aircraft Engine Research Laboratory remotely operating a Wright R-3350 engine in the tunnels test section. Four of the engines were used to power the Boeing B-29 Superfortess bomber. (Courtesy of NASA Glenn Research Center.)

ALTITUDE WIND TUNNEL, 1944. The Westinghouse 19XB turbojet is pictured inside the Altitude Wind Tunnel test section at the NACA Aircraft Engine Research Laboratory. In 1943, the 19A engine became the first operational US-designed jet engine and the only US turbojet incorporated into an aircraft during World War II in Europe. (Courtesy of NASA Glenn Research Center.)

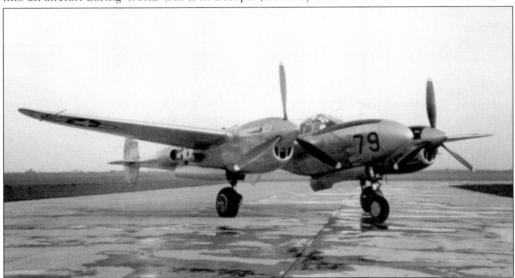

LOCKHEAD P-38J LIGHTING, 1945. Pictured here is a P-38J, which was a high-altitude interceptor during World War II. The NACA Aircraft Engine Research Laboratory was asked to determine the amount of ice formation on the induction system of the turbosupercharger engines. Closing the intercooler flap added protection against the ice by blocking ingestion and increasing heat. (Courtesy of NASA Glenn Research Center.)

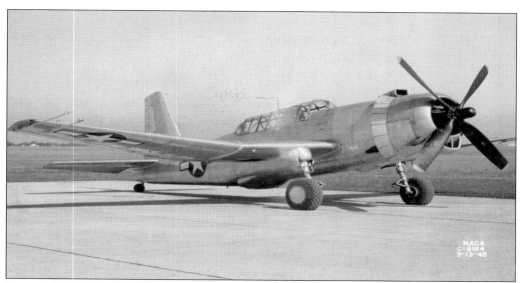

VULTEE VA-31C VENGEENCE, 1945. The photograph shows a YC-31C dive bomber that was used by the British in the Pacific during World War II. The NACA Aircraft Engine Research Laboratory was asked in 1943 to study the engine's heat distribution problems. There were improvements to the fuel injection and cooling system, but some of the modifications would not be changed until after the war. (Courtesy of NASA Glenn Research Center.)

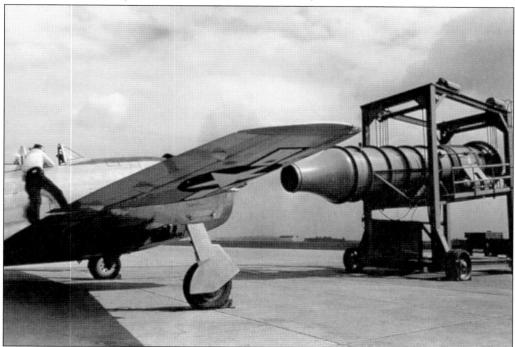

GROUND TESTING, 1945. A Republic P-47G Thunderbolt is pictured undergoing ground testing, with a large blower on the hangar apron at the NACA Aircraft Engine Laboratory at the Brook Park site. The blower could produce air velocities up to 250 miles per hour. This simulated takeoff power eliminated the need to risk flights and untried engines. (Courtesy of NASA Glenn Research Center.)

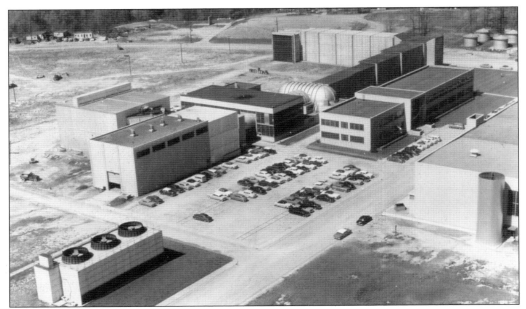

EXPANDED ALTITUDE WIND TUNNEL, 1945. This photograph shows an expanded wind tunnel that included the lab's first supersonic wind tunnel that was added to the complex. The Altitude Wind Tunnel was the nation's only wind tunnel capable of studying full-scale engines in simulated flight conditions. (Courtesy of Cuayahoga County Public Library.)

NACA WARTIME SAFETY POSTER, 1945. The Aircraft Engine Research Laboratory established a Safety Office in 1942 to coordinate and oversee safety-related activities. The management required six-day workweeks without overtime and the elimination of holidays. Because of these strict work conditions workplace injuries were a threat to maintaining the military aeronautics work. (Courtesy of NASA Glenn Research Center.)

GUARD HOUSE, 1945. A vehicle is pictured leaving a guard house at the Aircraft Engine Research Laboratory on August 14, 1945. At 7:00 p.m. that evening, President Truman announced that Japan had accepted terms for surrender and World War II was over. (Courtesy of NASA Glenn Research Center.)

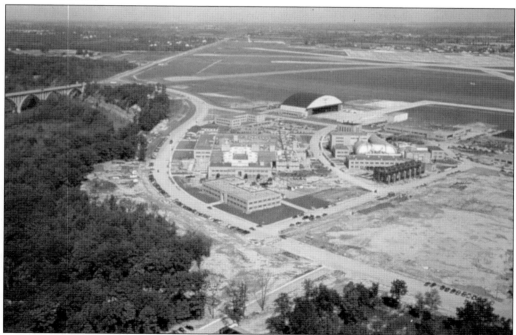

FLIGHT PROPULSION RESEARCH LABORATORY, 1946. This photograph shows the expansion of the site from a farmhouse with Cleveland Municipal Airport located at the top of the photograph. The initial campus contained the following: Engine Research Building, Fuels and Lubricants Building, Administration Building, Engine Propeller Research Building, Altitude Wind Tunnel, and Icing Research Tunnel. (Courtesy of NASA Glenn Research Center.)

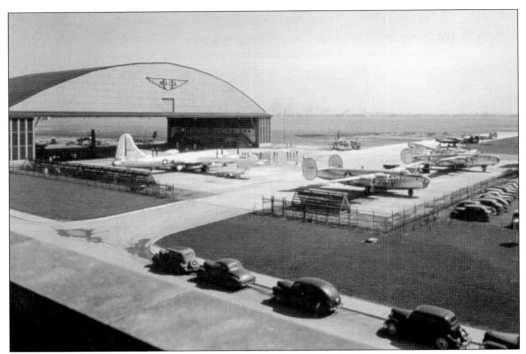

LEWIS LABORATORY, 1946. This photograph shows the fleet of military aircraft that was used in the 1940s for research at the Fight Propulsion Research Laboratory. During the war, these aircraft supported three actions that included improve performances of reciprocating engines, better fuel additives/mixtures, and dicing systems. (Courtesy of NASA Glenn Research Center.)

FLIGHT PROPULSION RESEARCH LABORATORY, 1948. The entrance to the laboratory is pictured here. On October 1, 1958, the lab was incorporated into the new NASA space agency. It was renamed the NASA Glenn Lewis Research Center, and following John Glenn's flight on the space shuttle, the name changed on March 1, 1999, to the NASA Glenn Research Center. (Courtesy of Cleveland Memory Project.)

ICING RESEARCH TUNNEL, 1949. This icing tunnel was designed in the early 1940s to study ice accretion on airfoils and models. The Carrier Corporation designed a refrigeration system that reduced temperatures to -46 degrees Fahrenheit. The tunnel's drive fan generated speeds up to 400 miles per hour. (Courtesy of NASA Glenn Research Center.)

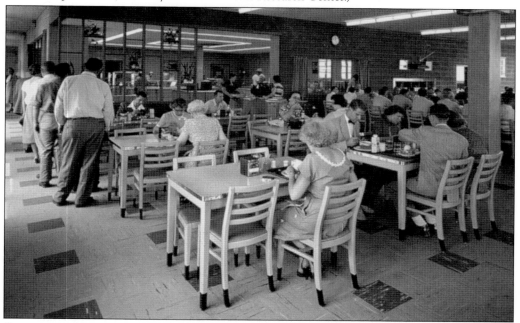

CAFETERIA AT LUNCHTIME, 1952. This photograph shows the Lewis Flight Propulsion Laboratory cafeteria. Employees could purchase bakery goods to take home. Services were expanded to include a lunch counter and food cart that ferried meals to the facilities. The cafeteria served nearly 1,600 daily meals. (Courtesy of NASA Glenn Research Center.)

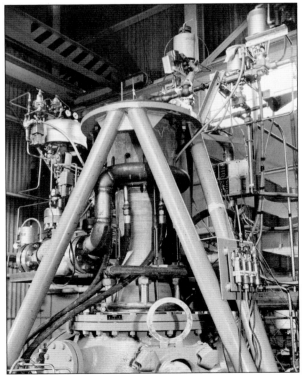

ROCKET ENGINE TESTING FACILITY, 1957. Pictured is the NASA Rocket Engine Test Facility (RETF), which started construction in 1955 on land that was formerly part of the Cleveland Municipal Airport. In 1940, the National Advisory Committee on Aeronautics selected 200 acres of the airport site for the construction of an Aircraft Engine Research Laboratory. RETF did postwar missile development and tested rocket engines and auxiliary equipment. (Library of Congress.)

NASA ROCKET TESTING, 1957. This photograph shows the Rocket Engine Testing Facility, Building No. 202, NASA Glenn Research Center in Brook Park, Ohio. Note that Stand A has a rocket engine. This facility was the largest high-energy rocket engine test facility in the United States. (Library of Congress.)

SECTIONAL VIEW OF HIGH-ENERGY ROCKET TEST FACILITY

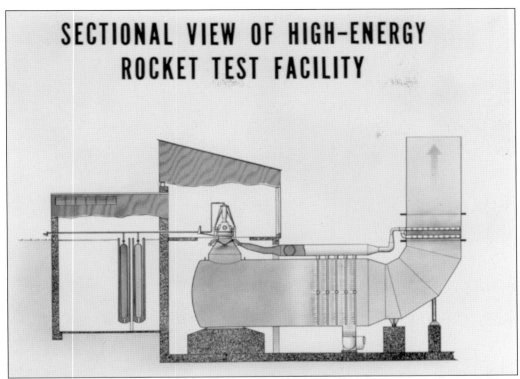

TEST STAND A, 1957. This drawing shows a sectional view of a high-energy rocket test facility, found in Building No. 202 at the NASA Glenn site, which was the start of the space exploration program at the center. The control center was housed in Building No. 100, and the test cell was in Building No. 202. (Library of Congress.)

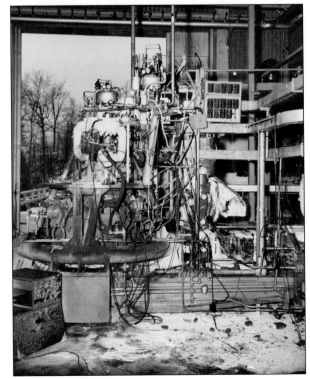

NASA ROCKET TESTING, 1958. This photograph shows Building No. 202 test cell with damage from fire or explosion during rocket engine testing, which helped to refine the US rocket propulsion system. Building No. 202 was a part of the original Rocket Engine Test Facility construction. (Library of Congress.)

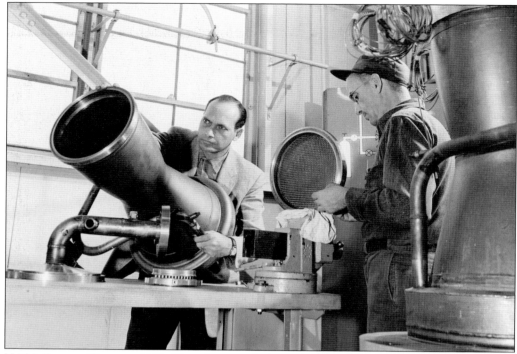

NASA Rocket Damage, 1958. This photograph shows Building No. 202 test stand with damage to a 20,000-pound-thrust rocket engine related to failure during testing. The facility was designed to permit up to three minutes of rocket engine operation that led to fine tuning the testing procedures. (Library of Congress.)

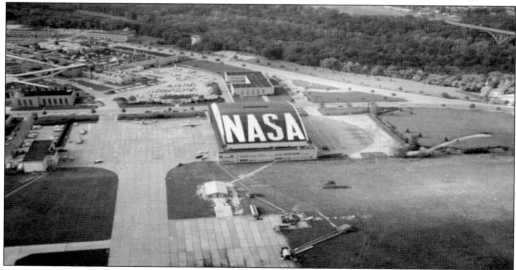

NASA Glenn Research Center, 1958. This photograph was taken six years after the center was built at the Brook Park site adjacent to the Cleveland Hopkins International Airport. Today, the main campus is 350 acres with 140 buildings and 500 specialized research and test facilities with over 3,000 employees that are mostly engineers and scientists. (Courtesy of NASA Glenn Research Center.)

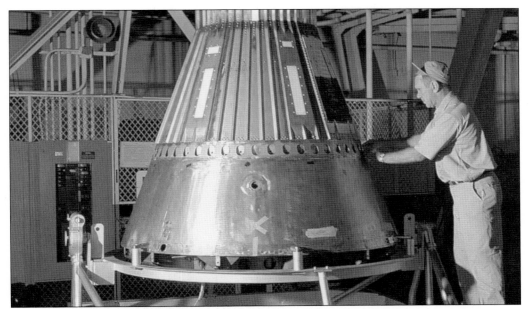

MERCURY CAPSULE CONSTRUCTION, 1959. The photograph shows a NASA mechanic securing an afterbody to a Mercury capsule in the hangar at the center. The capsule was one of two built at the Lewis Center, which was scheduled for launch for September 1959. The center constructed the capsule's lower section, and the technicians were responsible for assembling the entire capsule. (Courtesy of NASA Glenn Research Center.)

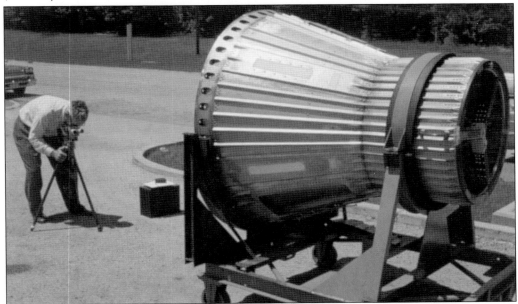

PROJECT MERCURY CAPSULE, 1959. This is a Mercury capsule that was constructed by the Lewis Research Center in Brook Park. The engineers and mechanics built two of the capsules for launches in September 1959. This was an early attempt in Project Mercury to use a full-scale Atlas booster to simulate the reentry of a mock-up Mercury capsule without actually placing it in orbit. (Courtesy of NASA Glenn Research Center.)

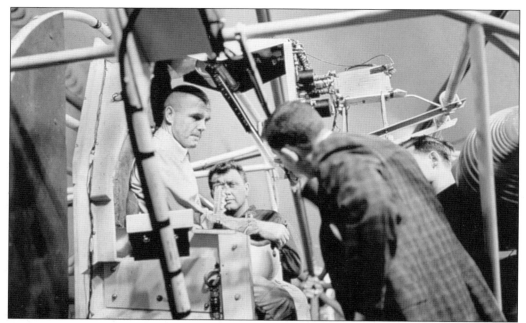

SPACE TEST INERTIA FACILITY, 1960. The photograph shows Mercury astronaut John Glenn preparing for a test inside the Altitude Wind Tunnel. The device was designed to train Project Mercury pilots to bring a spinning spacecraft under control. The rig was spun on three axes from 2 to 50 rotations per minute. (Courtesy of NASA Glenn Research Center.)

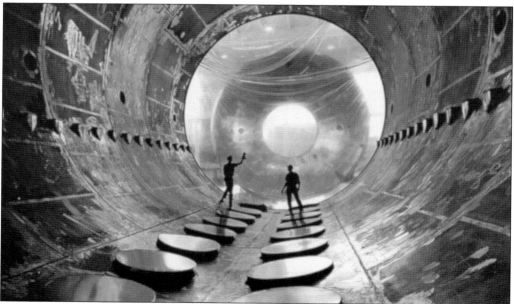

ELECTRIC PROPULSION LABORATORY, 1961. Here, the 20-foot diameter vacuum is where researchers had been studying different electric rocket propulsion methods since the mid-1950s. The laboratory contained two large vacuum tanks capable of simulating a space environment. The larger 25-foot diameter tank included a 10-foot diameter test compartment to test electric thrusters with condensable propellants. (Courtesy of NASA Glenn Research Center.)

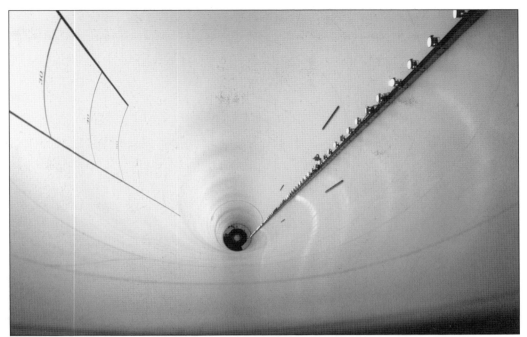

NASA Zero Gravity Chamber, 1974. The photograph shows the Zero Gravity Chamber that is still being used by researchers from around the world to study the effects of microgravity from Earth. Built in the ground, the chamber houses a 432-foot drop tower, making it the world's largest drop tower of its kind. It provides test articles a near-weightless environment for 5.18 seconds. (Courtesy of NARA.)

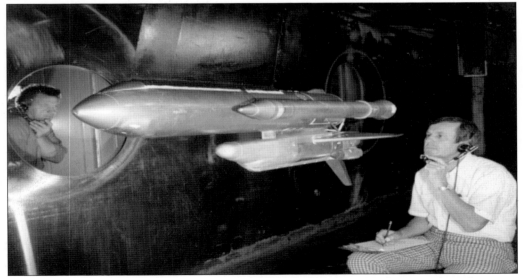

Space Shuttle Model, 1975. The photograph shows an engine measuring heat transfer and pressure distributions around the orbiter's external tank and solid rocket booster where the shuttle model's main engines and solid rockets were fired during the tests, then just the main engines, as a means of simulating a launch. The researchers conducted 163 runs in the 10-by-10 wind tunnel during the testing program. (Courtesy of NARA.)

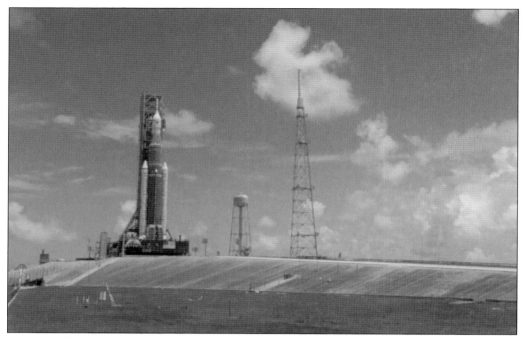

ARTEMIS I, JUNE 2022. This photograph shows the Artemis Space Launch System (SLS) and Orion spacecraft atop the mobile launcher at Launch Pad 39B at NASA's Kennedy Space Center in Florida that was launched on November 16, 2022. The mission was to check out the systems before crew fly aboard Artemis. The NASA Glenn Research Center had been contributing research on the project since 2015. (Courtesy of NASA Glenn Research Center.)

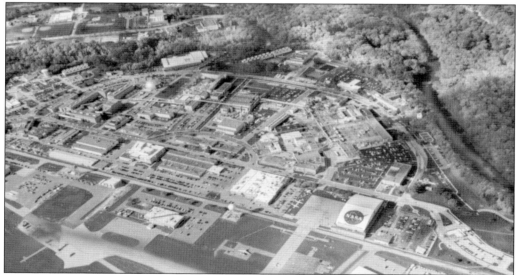

NASA GLENN RESEARCH CENTER, 2022. This aerial photograph shows the grounds and buildings that have evolved since NACA's 1941 farmhouse. Adjacent to the Cleveland Hopkins International Airport, the facilities are in the cities of Brook Park and Cleveland. The center is situated on 350 acres, which was once Brook Park farmland, and maintains more than 150 buildings. (Courtesy of NASA Glenn Research Center.)

Five

CLEVELAND TANK PLANT

In 1950, the Korean War prompted the US Defense Department to contract with General Motors Cadillac Division to build tanks for the US Army at the former Bomber Plant in Brook Park. When Cadillac started production, it was called the Cadillac Tank Plant, but most people referred to it as the Cleveland Tank Plant. During the Korean War, the plant manufactured the M14 Bulldog light tank and the M42 Duster Twin 40-millimeter Gun Motor Carriage. The peak employment at the Brook Park site was more than 6,000 workers.

The plant needed a place for field testing and choose a location near Hinkley, Ohio, approximately 15 miles south of the plant. The test site was called the Cadillac Ordnance Proving Ground, where the field area had a hilly terrain, deep ravines, and water hazards, and when it would rain, it was the ideal location to test the tanks' maneuverability.

In 1959, the plant was closed for short period of time but was reopened by Cadillac when it was awarded contracts by the US government to build the self-propelled howitzers M108 and M109 and the M114 Armored Personnel Carriers. In 1965, GM management moved to the Allison Division where the M551 Sheridan Tank was manufactured until 1972, when Congress decided to discontinue the program. The Defense Department was going to sell the Brook Park plant, and the Park Corporation ultimately bought the facility. In 1985, it was turned into the International Exposition Center, which was said to be one of the largest exhibition facilities in the world.

The Cleveland Tank Plant was another milestone for Brook Park's employment pattern where more than 6,000 workers contributed to the military's war effort to build tanks for the Korean and Vietnam conflicts until 1972. This chapter includes photographs of how Brook Park once again met the war needs of the country, in this case with a major contribution to the Korean and Vietnam Wars by supplying the military with the needed armored vehicles to fight ground attacks.

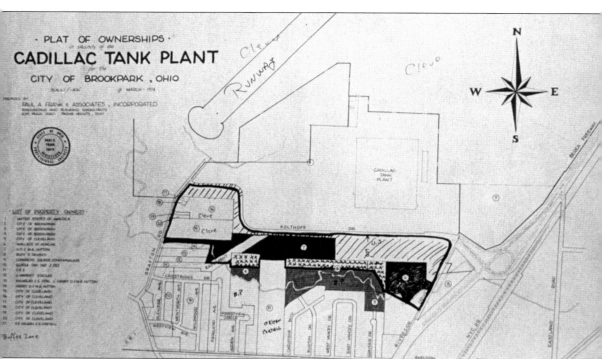

SITE MAP, 1974. This site map shows the plot of ownership of the former Cleveland Bomber Plant (1942–1945) that was 2,270,000 square feet. It manufactured Boeing's B-29 Superfortress component parts that were shipped to final assembly plants across the country. In 1950, the plant was converted into the Cleveland Tank Plant to manufacture armored vehicles for the Korean and Vietnam Wars (1950–1972). The brick front office area was 148,030 square feet, and in the background were the runways of the Cleveland Municipal Airport. The closeness of the airport runway was essential for parts and equipment shipments of over 18,000 armored vehicles. Plus, there were railway spurs to move the tanks to their next destinations. In 2000, there was an attempt at airport expansion that eliminated over 300 homes. Unfortunately, the airport expansion did not occur, and the land today is vacant. (Courtesy of Cleveland Memory Project.)

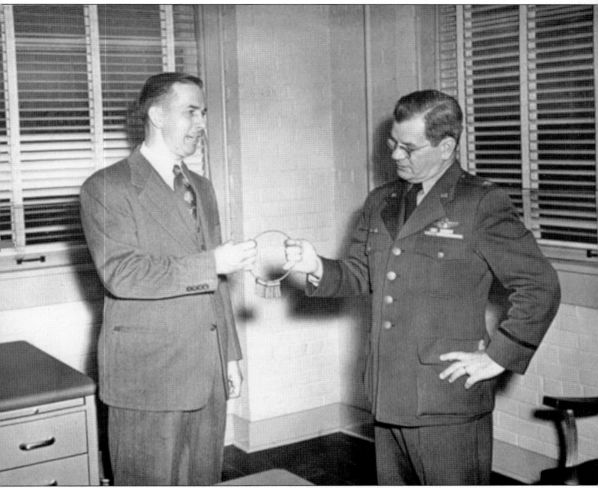

CLEVELAND TANK PLANT, 1950. E.N. Cole, works manager of the Cleveland Tank Plant (formerly Schlegel Air Force Plant) Cadillac Motor Division, General Motor Corporation, accepts the keys to the sprawling establishment adjacent to Cleveland Airport from Col. C.A. Bassett, commanding officer of the 2240th Air Force Reserve Training Center. The facility was the former Cleveland Bomber Plant at 6300 Riverside Drive in Brook Park, Ohio, and was owned by the US Department of Defense during World War II. The Air Force officially terminated its activities at the plant November 10, 1950. The main floor of the former Bomber Plant was used as a storage area, and before the plant could be readied for production, 159 carloads of beans had to be removed. The beans were stored in the government-owned plant by the Federal Surplus Commodities Corporation. (Courtesy of Cleveland Memory Project.)

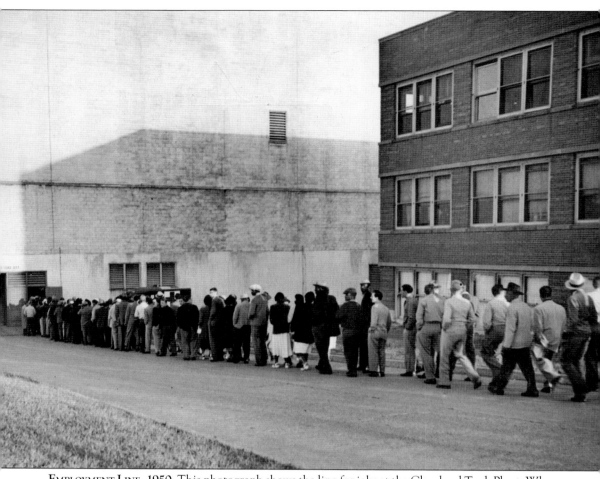

Employment Line, 1950. This photograph shows the line for jobs at the Cleveland Tank Plant. When the Korean War began, the former bomber plant, which was still owned by the US government, was reopened as the Cleveland Tank Plant. The photograph shows the line of potential workers from the village of Brook Park and the greater Cleveland area applying for employment; it was estimated that there would be a need for 6,000 jobs to build the armored vehicles at the plant, which was being managed by Cadillac Motor Car Division of General Motors, later Chrysler, and then Allison Division of General Motors. The tank plant was so massive that there were basement levels used for manufacturing purposes, and one basement had a large pool for testing water-tightness of the completed tanks. This influx of workers expanded the housing needs of the village of Brook Park and the surrounding communities. (Courtesy of Cleveland Public Library Photograph/Collection.)

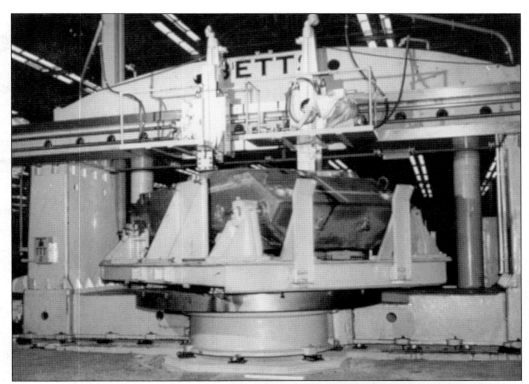

VERTICAL BORING MACHINE, 1951. Pictured here is a 24-foot Betts Vertical Boring Mill at the Cleveland Tank Plant as it machines an 84-inch diameter surface for mounting the tank's 20-ton turret ring and race assembly. Tolerances down to thousandths of an inch could be held on this large surface. (Courtesy of Cleveland Memory Project.)

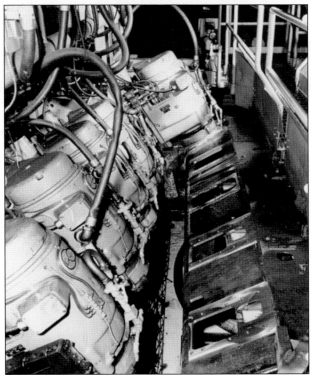

GRIND MACHINE, 1952. This photograph shows the Cleveland Tank Plant of Cadillac Division of General Motors' Queen Mary grind machine made by the Wean Equipment Corporation of Youngstown, Ohio. The company was a manufacturer of equipment that was used to process and finish flat rolled steel, iron rolls, iron castings, and stream hydraulic presses. (Courtesy of Cleveland Memory Project.)

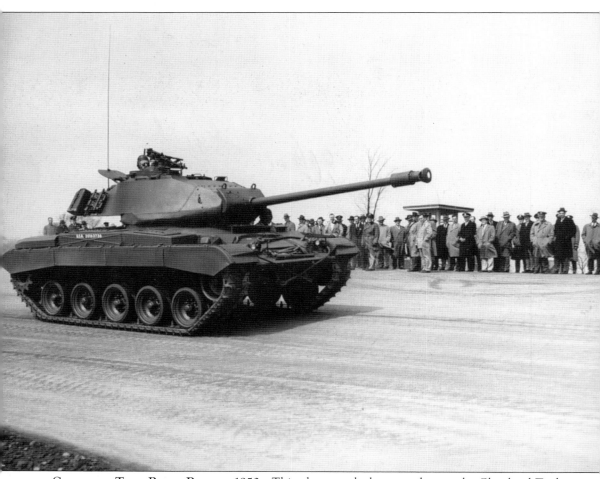

CLEVELAND TANK PLANT PARADE, 1950s. This photograph shows workers at the Cleveland Tank Plant. In the 1950s, the plant manufactured the M41 Walker Bulldog Light Tank, M56 Scorpion Self-Propelled Anti-Tank Gun, and the M42 40-millimeter Self-Propelled Antiaircraft Gun, which were field tested either at the same site near the plant or at the larger site at the Medina Tank Testing Grounds south of the plant near Hinkley, Ohio. The tanks produced at the Cleveland Tank Plant by Cadillac Motor Car Division of General Motors were often on display and would parade in various locations around the greater Cleveland area, especially across the Lorain-Carnegie Bridge in Cleveland. The parade of tanks came just at the close of the Korean War, which was an illustration of the military mite of the United States that existed during and after the war. (Courtesy of Cleveland Memory Project.)

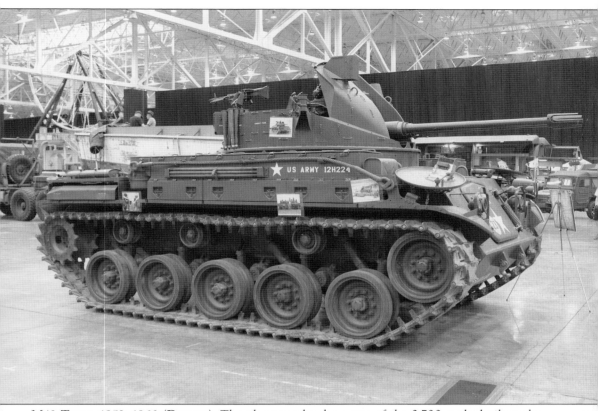

M42 TANK, 1952–1960 (DUSTER). The photographs show one of the 3,700 tanks built at the Cleveland Tank Plant by Cadillac Motor Car Division of General Motors. The tank was called the "Duster" by US troops in Vietnam because it could provide on point security, convey escort, and perimeter defense with its 40-millimeter guns, which were effective against infantry attacks and thus dusted away those attacks. It entered service in late 1953 and replaced a variety of different antiaircraft systems in armored divisions. The tank was equipped with an antiaircraft gun but it was basically ineffective against jet aircraft. The gasoline Dusters were susceptible to engine fires. On the positive side, crews found the tank was easy to maintain, plus it had a high ground clearance with a good suspension system that allowed it in most cases to withstand land mine explosions. (Courtesy of David Jackson.)

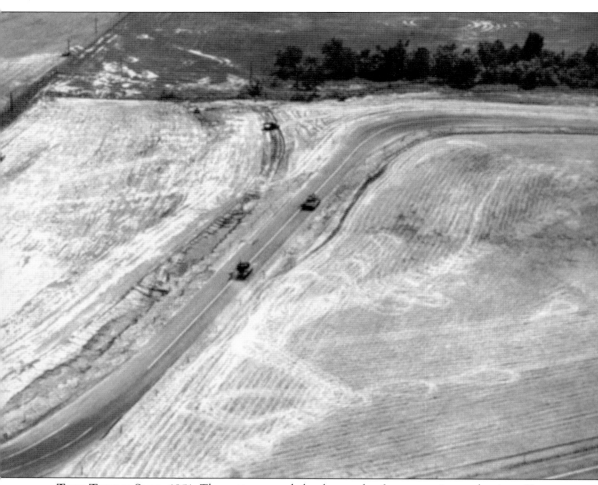

TANK TESTING SITES, 1951. The patterns made by the treads of maneuvering tanks give a Korean-battleground appearance to the test track at Cadillac Tank Plant at the Cleveland Airport. Daily, new light tanks are put through speed and mobility tests before being approved and sent to Korea. Another site was located 15 miles south of the Brook Park tank plant. In February 1951, Cadillac said the new testing location was ready for use and already had a tank on site. The new testing site was called the Cadillac Ordnance Proving Ground where it had a hilly terrain, deep ravines, switchbacks, dense brush, and water hazards. Two test courses were designed to replicate field positions. The testing site closed in 1970 as Cadillac was phasing out tank production at the Brook Park plant site. (Courtesy of Cleveland Memory Project.)

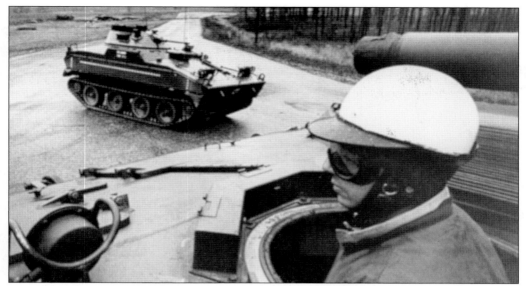

T-114 Tank Destroyer, 1961. This photograph shows a T-144 tank prototype on the Cleveland Tank Plant testing track. The prototypes were built between 1957 and 1960, and in 1961, it was decided to stop the development of the anti-tank version of the T-114 because it was found that the armor was too thin with the ammunition being exposed because of the thin layers of armor. (Courtesy of Cleveland Memory Project.)

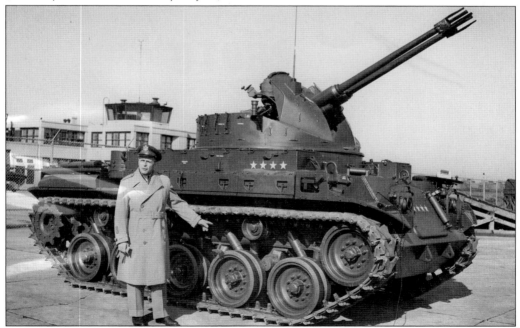

Gen. Matthew R. Ridgeway, 1953. Gen. Matthew R. Ridgeway was awarded the Gen. Benedict Cornwall gold medal for outstanding contributions to the national defense. He is pictured here inspecting the M42 gun motor carriage at the Cadillac Tank Plant. General Ridgeway "declassified" the secretly produced antiaircraft weapon. Two 40-millimeter guns are in a single mount. (Courtesy of Cleveland Public Library/Photograph Collection.)

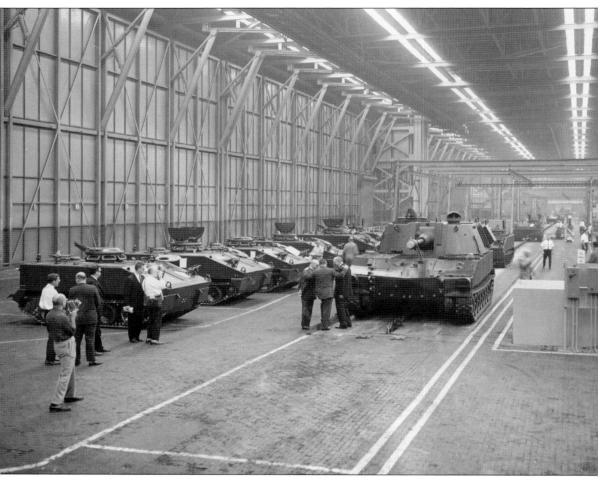

T195E1 Self-Propelled 105-millimeter Howitzer, 1962. The photograph shows preparations that were completed with the first production of T195E1 self-propelled 105-millimeter howitzer, which rolled off the final assembly line on October 17, 1962, at the Cadillac-operated Tank Plant. In the early 1950s, T-41s tanks were rolling off the assembly line at the plant where the T-41 was a light prototype tank that was made in limited numbers. It could reach speeds up to 41 miles per hour and had a crew of four. It was later modified into the M41 Walker Bulldog. There were 5,467 M41 Walker Bulldog manufactured at the Cleveland Tank Plant from 1951 to 1954. The Bulldog was the original armored vehicle that was built at the Cleveland Tank Plant by Cadillac Motor Car Division of General Motors where the tank was noted for its durability and maneuverability. The tank was the first postwar light tank that saw worldwide service and was used by South Vietnamese during 1965. (Courtesy of Cleveland Public Library/Photograph Collection.)

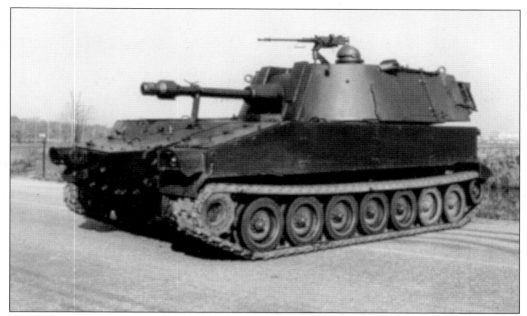

T195E1, 1962. The photograph shows the T195E1 after it was fully assembled at the Cleveland Tank Plant. It was one of the first in a new family of full-tracked, aluminum-armored vehicles mounting major caliber artillery weapons. In July 1963, the T195E1 received the military renaming of M108 105-millimeter Howitzer Self-Propelled. (Courtesy of Cleveland Memory Project.)

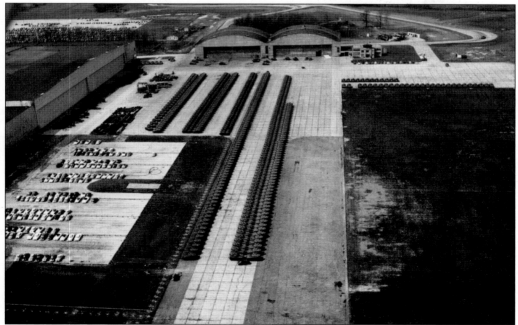

ARMY TANKS, 1965. The photograph shows tanks lined up at the Cadillac Tank Plant. The tanks were ready for shipment to the US Army. Prior to shipment, the tanks were field tested on a testing track in the background with a more extensive testing track near Hinkley, Ohio, 15 miles south of the plant. (Courtesy of Cleveland Public Library/Photograph Collection.)

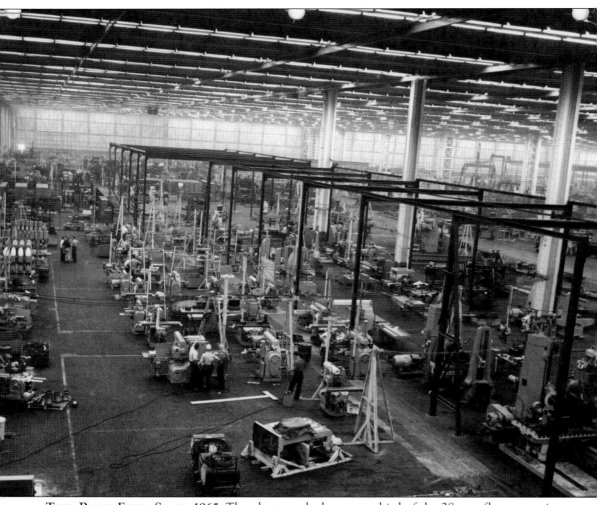

TANK PLANT FLOOR SPACE, 1965. The photograph shows one-third of the 28-acre floor space in the Cadillac Tank Plant being used with other space ready for use. The tank plant had more than 4,000 machines and fixtures, with some of them weighing 50 tons. The first floor of the plant was 1,258,000 square feet, second floor balcony 415,000 square feet, and the basement 597,000 square feet, totaling 2,270,000 square feet of manufacturing space. In August 1951, the main floor of the Cleveland Tank Plant as the Cadillac Motor Car Division took over the former Cleveland Bomber Plant. Before the plant could be readied for production, 159 carloads of beans had to be removed. Beans were stored in the government-owned plant by the Federal Surplus Commodities Corporation. (Courtesy of Cleveland Public Library/Photograph Collection.)

M551 Sheridan Tank, 1966–1970. Pictured here is one of the 1,662 tanks that were built at the Cleveland Tank Plant Allison Division of General Motors. It was classified as a light armored reconnaissance/airborne assault vehicle and was designed to land by parachute and go across rivers and was sent into combat service to South Vietnam in early 1967. (Courtesy of David Jackson.)

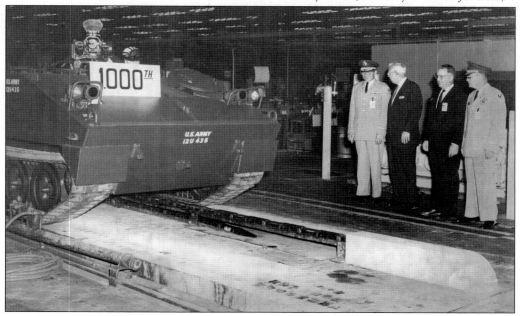

Tank Inspection, 1963. This photograph shows the 1,000th tank rolling off the assembly line at the Cleveland Tank Plant. The participants of the celebration are, from left to right, Col. Ralph M. McMahon, commanding officer, Cleveland Procurement District; Harold G. Warner, general manager of Cadillac and vice president of General Motors; George P. Elves, plant manager, Cleveland Ordnance Plant; and Maj. Jack W. Shaffer, officer-in-charge. (Courtesy Cleveland Public Library/ Photograph Collection.)

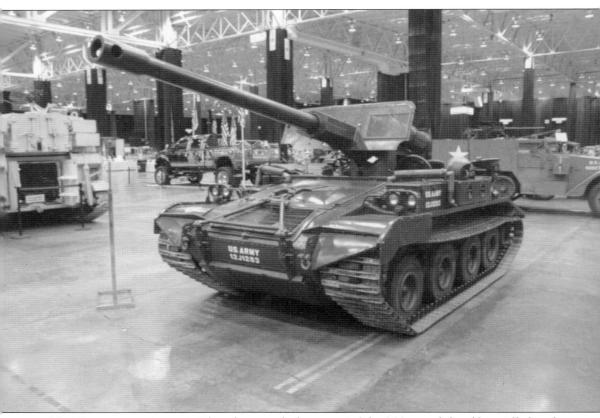

M56 Scorpion, 1953–1959. This photograph shows one of the 356 airmobile self-propelled tank destroyers that was manufactured by the Cadillac Motor Car Division of General Motors; it was deployed with the 173rd Airborne Brigade during the Vietnam War. Some of the drawbacks of the destroyer were that it did not have secondary armament and no protection for the four-man crew with armament that was basically no more than just a gun shield with a small a window for the driver. During the Vietnam War it was used in direct fire-support of the ground troops. It reached a maximum speed of 28 miles per hour and had a range 140 miles. While most of the M56s saw US military service, there were 87 purchased in 1966 by Morocco and five were used by the Spanish Marine Corps. (Courtesy of David Jackson.)

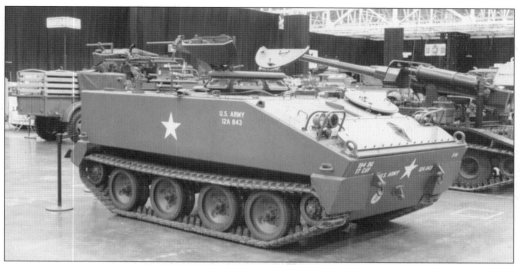

M114 Tank, 1962–1964. The photograph shows one of the 3,714 tanks built at the Cleveland Tank Plant by the Cadillac Division of General Motors that were deployed in the Vietnam War. It was found that during its operations the M114 armored reconnaissance vehicle was underpowered and had difficulty in cross-country operations and was removed from service in November 1964. (Courtesy of David Jackson.)

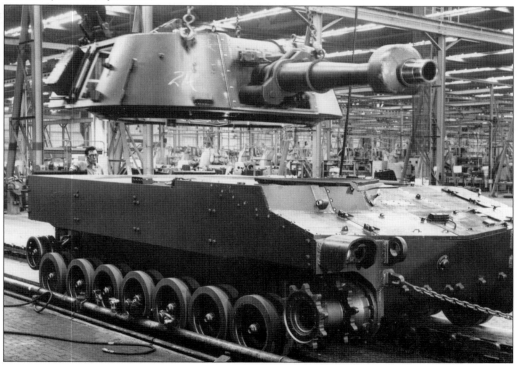

M109 Tank, 1966. The photograph shows the lowering of a turret to the tank hull on the assembly line at the Cleveland Tank Plant. The tank turret is the dome-like structure on the tank that connects the gun to the hull and rotates independently of the tank's hull, allowing the gun move, but not quite 360 degrees. (Courtesy of Cleveland Public Library/Photograph Collection.)

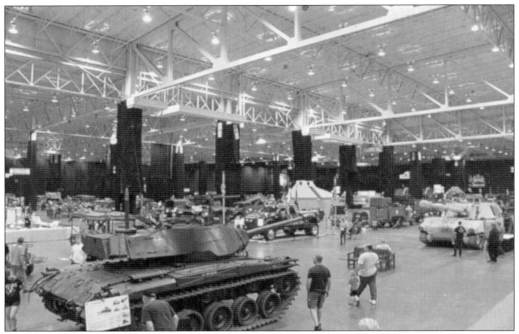

INTERNATIONAL EXPOSITION CENTER, 2017. This photograph shows the World of Tanks Cleveland Tank Plant Homecoming, June 22–24, 2017, where more than 18,000 armored vehicles were manufactured at the Brook Park site from 1950 to 1972. The black curtains in the background divided off a portion of the huge assembly section that was not needed for the show. (Courtesy of David Jackson.)

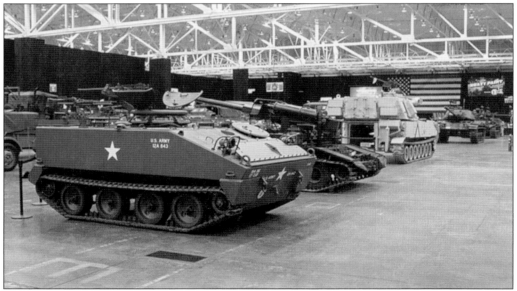

ARMORED VEHICLES, 2017. Five armored vehicles are pictured on display at the Cleveland Tank Show. From left to right, they are the M114 Command and Reconnaissance Carrier, M56 Scorpion Anti-Tank Gun, M109A3, M41 Bulldog, and the M42 Duster, all of which were built at the Brook Park site. (Courtesy of David Jackson.)

Six

FORD MOTOR COMPANY

After World War II, the Ford Motor Company was looking to produce a competitive new line of cars with a more powerful overhead valve engine, which meant increasing manufacturing capacity beyond Detroit. The competition was stiff, with many states and communities vying for Ford to locate at their proposed sites. Brook Park, Ohio, won the site competition because there was farmland, and the village was situated along the lakefront mainline of the New York Central Railroad and adjacent to the Cleveland Municipal Airport, and Cleveland was a port city with enhanced shipping capabilities that could move product across the Great Lakes.

The three Ford Motor Plant depictions show the Casting Plant (1951–2010), with 1.6 million square feet; Engine Plant No. 1 (1952 to present), with 1.6 million square feet; and Engine Plant No. 2 (1955–2012), with 1.5 million square feet. At peak production, the three plants had close to five million square feet of manufacturing space. A fourth plant, the Aluminum Casting Plant, was attached to Engine Plant No. 2 and was built in 2000 and closed in 2003 because it was too expensive to operate.

The launch of the plants in the 1950s propelled Brook Park to become a powerful manufacturing center for the Ford Motor Company. This new site was second only to the River Rouge complex in Detroit but with more automation efficiency. Throughout the 1950s, 1960s, and 1970s, the Brook Park complex was the heart of the Ford engine production.

An important union leader of UAW Local No. 1250 was local resident Michael Gammella. He became a full-time union official in 1981 and, through the years, served as editor and photographer of the union newspaper, the *Enlightener*; executive board member, vice president of UAW's Community Action Program; and union president, just to name a few of his contributions, which he parlayed into serving as Brook Park City Council member/president and as mayor of Brook Park City from 2018 to 2021.

The photographs in this chapter show the evolution of the Ford plants, which created another industrial hub in Brook Park by providing jobs for the area with over 15,000 employees working at the plants in the 1970s.

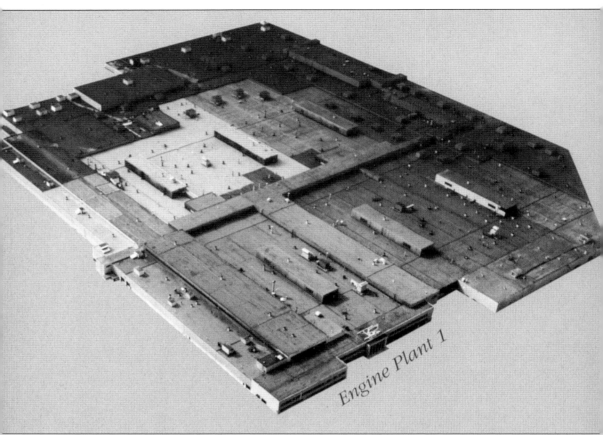

Engine Plant 1

ENGINE PLANT NO. 1, 1952 TO PRESENT. This image shows the size of the engine manufacturing space of over 1.6 million square feet. The plant produced Ford's first overhead valve engine, known as the Lincoln Y-block V-8. Automation was the major thrust of the plant where the manual loading and unloading of production was inefficient. That changed to the block line that had a series of 26 machines linked together so that in the end there would not be any manual loading and unloading of cylinder blocks. Most noteworthy is that the plant produced the Edsel series engine, but in preparation, the six-cylinder operations were moved to Engine Plant No. 2. Today, there are over 1,700 employees that are producing engines for car models and pickups. The Ford engine plant when it opened in 1952 was heralded as the world's most highly automated manufacturing facility. (Courtesy of *The Cleveland Site: History 1950–1997.*)

Water Tower and Powerhouse, 1951. The photograph shows the 187.5-foot water tower, the tallest structure on site. It provided a reservoir of 750 gallons of water. City water was used to operate the boilers at a cost in excess of $1 million per year. Adjacent to the water tower was the powerhouse, which transmitted electricity, compressed air, steam, and 13,200-volt electric lines through giant arteries pipes to each of the plants. The pipe lines ran through utility tunnels, one to the Casting Plant, the other to Engine Plant No. 1, and, for a half a mile along an overhead trestle, to Engine Plant No. 2. The powerhouse complex used on average 45 million kilowatt hours per month, at a cost $2 million per month. At the site, people could watch nighttime movies on a drive-in screen, which later was eliminated. (Courtesy of *The Cleveland Site: History 1950–1997.*)

GENERAL SERVICES BUILDING, 1951. This photograph shows the facility under construction. The construction with long horizontal lines intersected by the second floor was modern for the 1950s. The building after construction housed the Industrial Relations Staff Office for the Casting Plant and Engine Plant No. 1. Hospital facilities included a main examining, a room treatment of minor fractures, and a room for eye and ear examinations. The general medical assistance for employees had a full-time industrial physician and several nurses. The employees would receive a physical at the General Services Building prior to working at one of the plants. UAW Local Union No. 1250 and Ford management together sponsored safety programs for employees that worked at the plants with the goal of eliminating a visit to the General Services hospital facilities. (Courtesy of *The Cleveland Site: History 1950–1997.*)

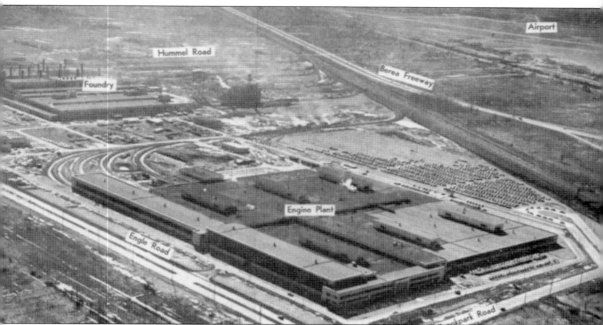

New Industrial Giant, 1952. The aerial photograph, looking southwest, shows the new Engine Plant No. 1, Iron Casting Plant, powerhouse, and General Services Building. The Ford Motor Company's industrial site covered 203 acres in the village of Brook Park. The automated Engine Plant No. 1 fronts 900 feet along Brook Park Road. The Casting Plant started casting with production moving forward at a fast pace. Parking facilities for 3,300 cars can been see on the backside of the engine plant. The addition of Engine Plant No. 2 in 1955 made the village of Brook Park site Ford's second-largest facility and, with future expansion, increased the manufacturing space to over five million square feet with peak employment being over 15,000 employees. The enormity of site moved the village of Brook Park to becoming a major industrial site during the postwar years, which meant a housing boom in the area with new people moving to the village to work at the Ford plants. (Courtesy of *The Cleveland Site: History 1950–1997.*)

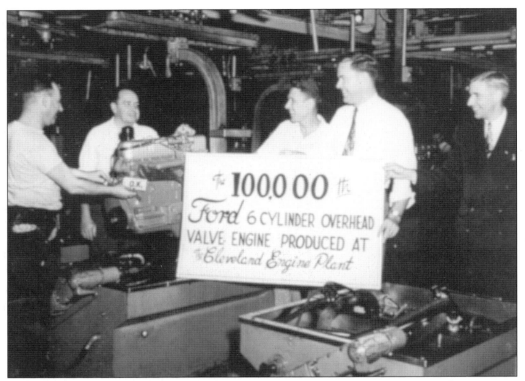

100,000 MILESTONE, 1952. This photograph shows the celebration of the one year 100,000 milestone of the six-cylinder overhead valve engine at the Engine Plant No. 1. Behind the 215 CID (cubic-inch displacement) engine is chief mechanic and superintendent of the assembly line Larry Zerbe. Holding the sign is Doug Rowe, and to the right is Frank Leach, production control manager. (Courtesy of *The Cleveland Site: History 1950–1997.*)

HENRY FORD II VISITATION, 1953. Henry Ford II reviews the new Mercury V-8 assembly line with Doug Rowe at Engine Plant No. 1. It was said that Ford was active in visiting the Ford plants in Brook Park, which was recognition of the importance of the plant's operations. (Courtesy of *The Cleveland Site: History 1950–1997.*)

ENGINE PLANT NO. 1, 1953. The photograph shows "Mr. Automation," vice president for manufacturing Del Harder, wearing the hat. He is pictured with his staff, from left to right, Logan Miller, John Dykstra, and R.H. Sullivan. The team chose Brook Park, Ohio, as the site for the new engine plant automation delivery system. (Courtesy of *The Cleveland Site: History 1950–1997.*)

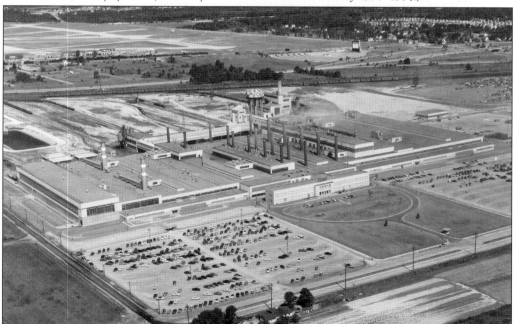

FORD ENGINE PLANT NO. 1, 1953. This aerial photograph shows the engine plant one year after completion; it had become a major auto-parts factory in the Midwest, located in Brook Park, Ohio. In the background was farmland where Engine Plant No. 2 was built and opened in 1955. (Courtesy of Cleveland Public Library/Photograph Collection.)

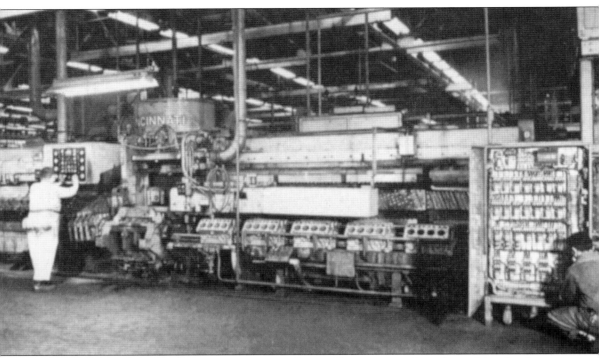

BROACH AUTOMATED MACHINE PROCESS, 1955. Pictured here is a giant broach machine that began the automated V-8 machining process. To the left is the operator control panel, and to the right was the machine's electrical nerve center. The broach machine was a cutting tool that was used to cut specific shapes or remove specific area from a workpiece such the honing of the engine blocks. With the engine blocks, the broach is pushed or pulled, removing material to create the specific features of the block. The broach machine was able to cut exact shapes versus using other machinery that took more time to do the same function. Given that this was 1955, it was a major automation accomplishment by Ford that allowed for bulk precision machining that was used to cut complicated shapes. (Courtesy of *The Cleveland Site: History 1950–1997.*)

BROOK PARK SITES, 1954. This springtime photograph depicts Engine Plant No. 1, Casting Plant, and the powerhouse. The airport was to the west, Brook Park residential area to the north, open fields to the east, and Engine Plant No. 2 under construction to the South. (Courtesy of *The Cleveland Site: History 1950–1997.*)

BROOK PARK FORD MOTOR, 1965. This aerial view of Engine Plant No. 1 and the Casting Plant shows full employment with the many cars parked at various locations around the plants. The Casting Plant is seen in the background with smokestacks steaming during the summer. (Courtesy of Cleveland Public Library/Photograph Collection.)

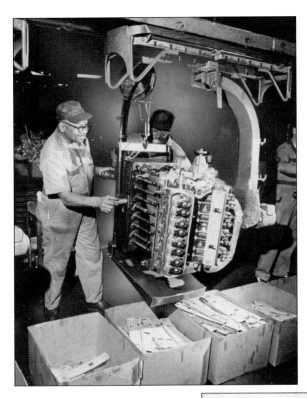

ENGINE PLANT NO. 1, 1968. Otis Wilson Jr. and Clarence Rogers are pictured using multiple nut runners to tighten the bolts on the oil pan as it goes down the assembly line. The assembly line was a major component of the Ford Motor Company automation process at the three Brook Park plants. (Courtesy of Cleveland Public Library/Photograph Collection.)

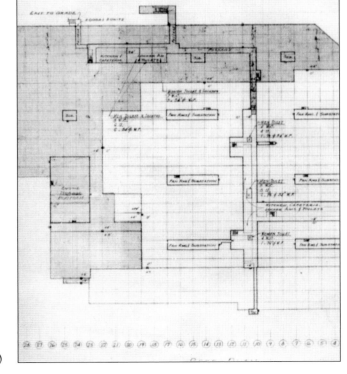

ENGINE PLANT NO. 1 EXPANSION, 1977. This diagram shows the expansion program (shaded area). Added was an indexing assembly line and automated bot test and machining capability which increased 302/5.0-liter engine annual capabilities from 864,000 to 1.6 million units. (Courtesy of the Cleveland Site.)

4.9-Liter Electronic Fuel Injection (EFI) Engine, 1960s. This cutaway illustration shows the inner workings of the 4.9-liter Electronic Fuel Injection Ford engine with over eight million of the engines built at Engine Plant No. 1. The last 4.9-liter engine was assembled in October 1996. (Courtesy of *The Cleveland Site: History 1950–1997*.)

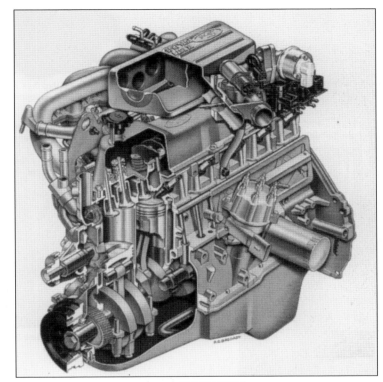

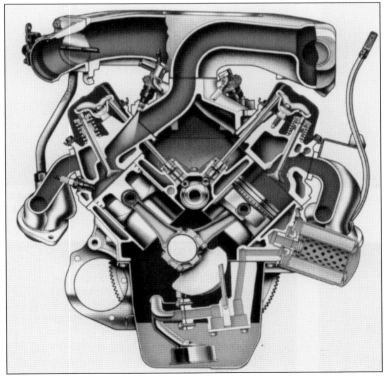

5.0-Liter High Output Engine, 1990s. This cutaway view shows the engine that powered the Ford Mustang, launched in 1961 at Engine Plant No. 1 as a 221 CID V-8 to power the Ford Fairlane and Mercury Meteor. Numerous changes over 35 years led to the manufacturing of over 20 million engines. (Courtesy of *The Cleveland Site: History 1950–1997*.)

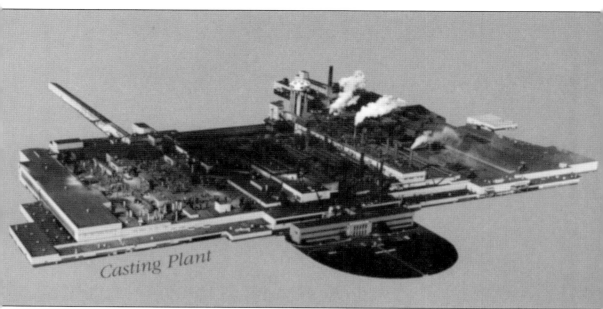

Casting Plant

CASTING PLANT, 1951–2010. The depiction of the casting plant shows what a massive structure it was with approximately 1.6 million square feet of manufacturing space. There was a need for relieving and supplementing the capacity of the Dearborn Iron Foundry, which led to the decentralization of foundry work. The plant produced cylinder blocks and heads, crankshafts, flywheels, and bearing caps for Ford vehicles. The plant used between 800 to 1,100 tons of virgin sand in the casting process, which resulted in approximately 350,000 tons sand used annually. The plant's peak production in the 1970s employed over 10,000 people which was 66.7% of the workforce of the three plants. In the end, there were over 34 million engines manufactured at the Brook Park site. (Courtesy of *The Cleveland Site: History 1950–1997.*)

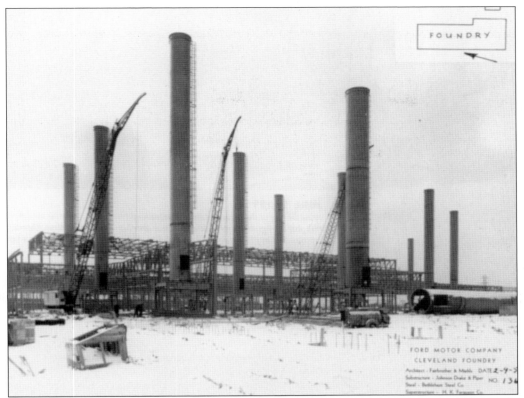

CASTING PLANT CONSTRUCTION, 1951. This photograph shows that most of the molding stacks were in place with the construction beginning in the core room and moved northward to molding, through melting, and finishing with the cleaning room. Nine spurs were run from the New York Central line, seven to the foundry and two to Engine Plant No. 1. (Courtesy of *The Cleveland Site: History 1950–1997.*)

CASTING PLANT, 1951. This photograph shows the massive construction of the casting plant one year after the groundbreaking. The cranes in the background are concentrated in the cleaning room with the last of the structural steel, and just behind them was the powerhouse. (Courtesy of *The Cleveland Site: History 1950–1997.*)

CASTING PLANT, 1952. This photograph from six months later shows that the casting plant's exterior was nearing completion. As the exterior is being completed, equipment was being installed inside. The first sample castings were poured on February 22, and the first mold line No. 2 was started on May 5, 1952. (Courtesy of *The Cleveland Site: History 1950–1997*.)

SAND STORAGE, 1952. This photograph shows the area where 54,000 tons of sand were stored indoors at the Casting Plant; the sand was shipped from mines in Michigan to the Ford docks on the Cuyahoga River. The sand was delivered to the storage bay by rail. (Courtesy of *The Cleveland Site: History 1950–1997*.)

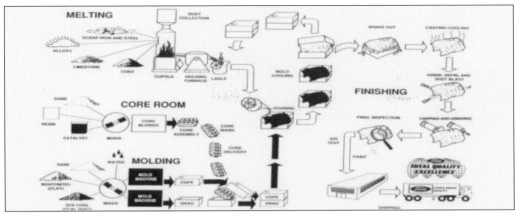

ENGINE BLOCK PRODUCTION PROCESS, 1950s. This illustration depicts the three main stages at the Casting Plant of core and mold making, metal refining, pouring, and finishing of engine blocks that are sent on to the finishing room where the castings were prepared for Ford's customers. (Courtesy of *The Cleveland Site: History 1950–1997.*)

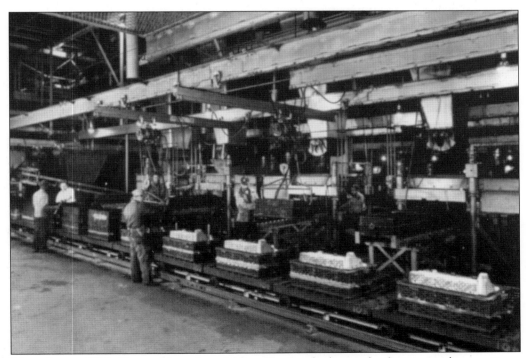

MOLD LINES, 1953. Pictured here is mold line No. 2, which was the first to produce castings. Finishers are transferring the molds to the conveyor where they are guided by pins onto the drag, and the molds are clamped on before molten melt is poured into the mold. (Courtesy of *The Cleveland Site: History 1950–1997.*)

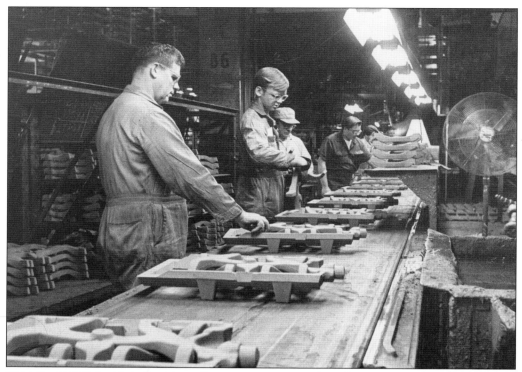

CORE LINES, 1953. This photograph shows the Core Block Assembly Line where the Casting Plant was equipped with 78 oil sand core blowing machines, which were arranged into 11 production lines, each with its own core baking oven. A pattern is pressed into sand and then extracted where it leaves a concave impression. Liquid metal fills this void and coils. (Courtesy of Cleveland Public Library/Photograph Collection.)

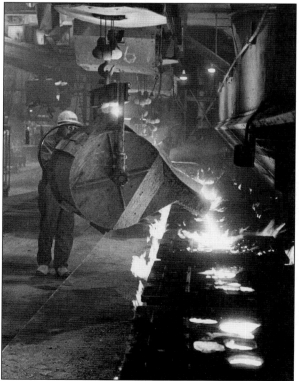

POURING HOT METAL, 1968. A worker at the Casting Plant pours hot metal into a mold. After the metal and mold were cooled, the metal part (casting) was removed from the mold and was roughly machined before heading for finishing and assembly. (Courtesy of Cleveland Public Library/Photograph Collection.)

CASTING PLANT CELEBRATION, 1964. Core employees point to the huge safety sign that tracked hours worked without injury. The plant set the world record in 1963 at 4,342,000 safe man hours attributed to the cooperation between UAW Local No. 1250 and management. (Courtesy of *The Cleveland Site: History 1950–1997*.)

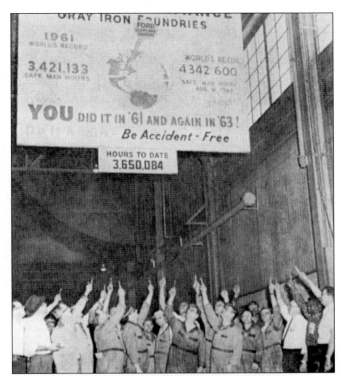

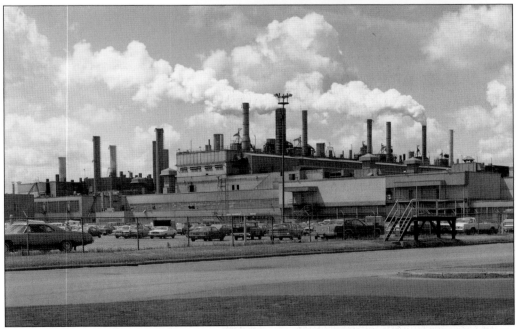

CASTING PLANT, 1979. The Casting Plant is pictured at peak production providing engine blocks of Engine Plants Nos. 1 and 2. The number of cars in the parking lot illustrated that the plant was at full production because of the continued emphasis on automation to increase production output. (Courtesy of NARA.)

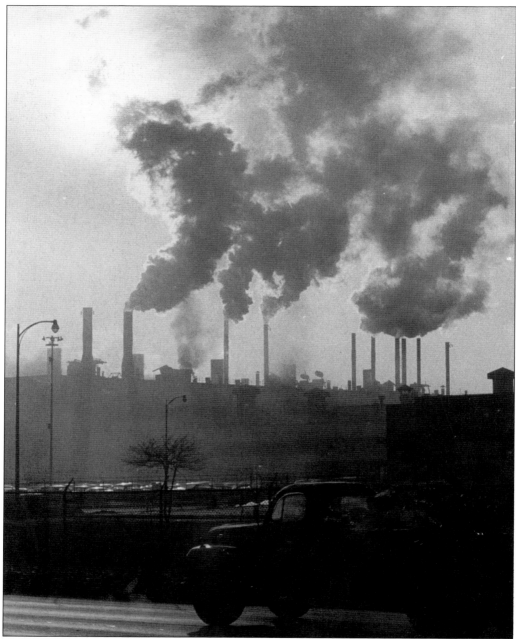

Foundry Going Full Steam, 1970s. This photograph shows visible clouds of steam discharged from the stacks of the Casting Plant in Brook Park. Normally in warmer weather, steam cannot be seen. The casting plant was the foundry that made engines blocks for the engines manufactured at Engine Plants Nos. 1 and 2. Over the years, the US Environmental Protection Agency fined the casting plant for emissions noncompliance, which forced the plant to make changes to the emissions from the plants. In 2008, the plant was fined $1.4 million for failing to upgrade certain air pollution equipment for cupola furnaces and mold lines, plus there were other fines for emission violations. (Courtesy of Cleveland Public Library/Photograph Collection.)

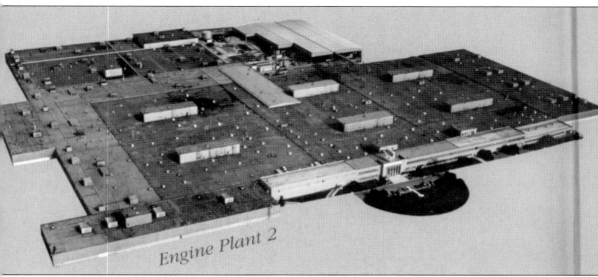

Engine Plant 2

CLEVELAND ENGINE PLANT NO. 2, 1955. The photograph shows the engine plant that began production operations in February 1955. Soon after the plant was opened, it received a 300,000 square feet addition, bringing the total floor space to 862,000 square feet. Eventually, it encompassed 1.5 million square feet. The plant began producing 272/293/312 family of V-8 engines. In 1957, they built the first gasoline engine for their truck line that included a 100,000-mile warranty, which was a first in the industry, and produced 50 engines daily at the plant. In March 1960, as the plant was at capacity producing 223 CID Six Cylinders (1952–1964) that were used in the Ford Fairlane, Ford Galaxie, and F-series trucks. The 292 CID V-8s (1955–1962) was the other engine manufactured at site that were used in Ford F-100 pickup trucks and the Ford Fairlane. (Courtesy of *The Cleveland Site: History 1950–1997.*)

1,000,000 ENGINES, 1957. This photograph celebrates 1,000,000 engines assembled at Engine Plant No. 2. Watching the final assembly operation of the 292-engine were Frank Maly, production manager, and Fred Meredith, plant manager, and assembler Robert Kuhn. Not to be outdone, it was a banner year in 1977 where a record of 1,866,000 engines were produced. (Courtesy of *The Cleveland Site: History 1950–1997.*)

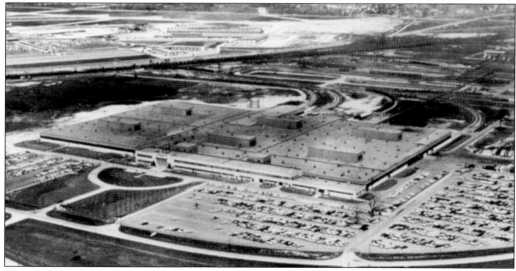

ENGINE PLANT NO. 2, 1960. This is an aerial view of the parking lots nearly full in March 1960, as the plant was at capacity producing 223 CID Six Cylinders (1952–1964) that were used in the Ford Fairlane, Ford Galaxie, and F-series trucks. The 292 CID V-8s (1955–1962) was manufactured at the site was used in Ford F-100 pickup trucks and Ford Fairlanes. (Courtesy of *The Cleveland Site: History 1950–1997.*)

INDIANAPOLIS 500, 1965. No. 82 Jimmy Clark pulls ahead of No. 1 A.J. Foyt on his way to victory in the 1965 Indianapolis 500. Both cars were powered by Ford engines from Engine Plant No. 2. There were 33 cars with eight of the 11 finishers, including the first four engines that were Ford V-8 powered, and the Ford engine of the winning car was driven by Jimmy Clark who shattered the 150-miles per hour (average barrier) as he went across the finish line. Eight out of the 11 finishers, including the first four finishers, were Ford V-8 engines made at Engine Plant No. 2. The Ford engines turned 498 horsepower by 8,800 rotations per minute, reaching 190 miles per hour on the straightaways. Only 6 of the 33 cars in the field had front engines, which was the first time in the 500 histories to have most of the cars with rear-engine machines. (Courtesy of *The Cleveland Site: History 1950–1997.*)

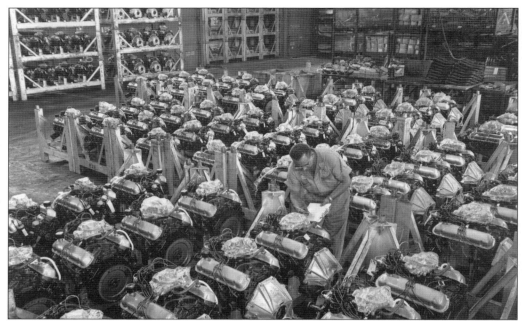

ENGINE RACKS, 1967. Completed engines are pictured set into metal racks at Ford's Engine Plant's shipping docks, awaiting movement by rail to the network of automobile assembly plants. Engine Plants Nos. 1 and 2 supplied more than 50 percent of Ford's engine requirements, with a combined output of 5,700 units daily. (Courtesy of Cleveland Public Library/Photograph Collection.)

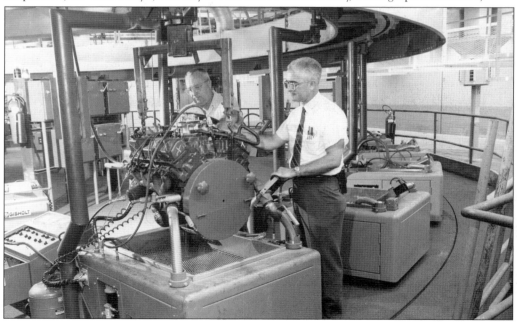

FORD ENGINE PLANT NO. 2, 1970. Employees use an engine test arm to examine parts on the engine block leading to quality control in the production process. This process became more automated in the future and continues today at Engine Plant No. 1. (Courtesy of Cleveland Public Library/Photograph Collection.)

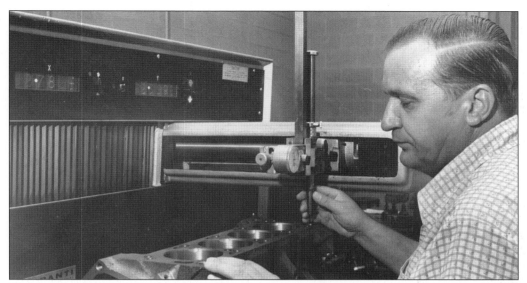

ENGINE CYLINDER INSPECTIONS, 1975. A layout inspector makes sure that the engine cylinders are in the right place in the block for proper performance. The inspector is pictured using a Ferranti tester to check the dimensions on a V-8 block for Ford's 351-CC engine. The engine was commonly referred to as the 351 Cleveland after the Brook Park Engine Plant No.2. (Courtesy of Cleveland Public Library/Photograph Collection.)

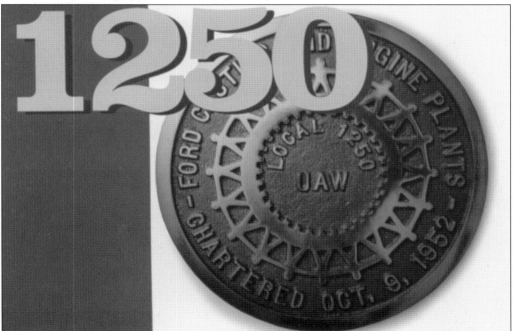

UAW UNION LOCAL NO. 1250, 1952. The union, starting in 1952, led the fight for multi-plant seniority protection, extra relief for fully paid health care, and benefit insurance. It pushed for such benefits as "25 and Out" for foundry workers, guaranteed annual wage, and safety issues and made sure that health benefits were always on the table for employees. (Courtesy of *The Cleveland Site: History 1950–1997.*)

MICHAEL GAMMELLA, 1980s–2021. Union president Michael Gammella is pictured here in 2005. He faced major obstacles with the eventual closing the Casting Plant and Engine Plant No. 2, plus Engine Plant No. 1 employing only 63 people. Mr. Gammella pushed Ford leadership, with the support of US senator Sherrod Brown, to think out of the box, and positioned the plant to manufacture a four-cylinder Eco Boost Engine and a six-cylinder Eco Boost engine, which created more than 1,700 jobs. Gammella was elected Ward One Council member in 1985 with the goal of trying to stop airport expansion that was displacing residents. An extension of his community involvement was seen when he became city council president (1990–2000 and 2006–2014) and then was elected mayor (2018–2021). Mayor Gammella brought a business approach to city government by bringing more green space to the community. He was a pioneer in industrial and community relations, always striving to maintain a strong workplace and a positive community culture. (Courtesy of Michael Gammella.)

BIBLIOGRAPHY

Cleveland Memory Project. *Cleveland Tank Plant and Brook Park Photos.* Cleveland State University. Michael Swartz Library. Special Collections.

Cleveland Public Library. *Brook Park, Ohio Area Photos: 1929–1966.* Library/Photograph Collection, Center for Local & Global History.

Cuyahoga County Public Library, Brook Park Branch. *Early Photos of Brook Park, Ohio.*

Jackson, David D. *Cleveland Tank Plant Photos.* Retrieved from usautoindustryworldwartwo.com, 2022.

Library of Congress. *Cleveland Municipal Airport Photos.* Prints and Photographs Division, Washington, DC. Retrieved from Survey HAER OH-2, 1968.

Library of Congress. *Rocket Engine Testing Facility.* Prints and Photographs Division, Washington, DC. Retrieved from Survey HAER OH-124 A, 1968.

Library of Congress. *You help build the B-29 Drawing.* Prints and Photographs Division, Washington, DC. Retrieved from https://www.loc.gov/item/90712740, 1945.

NARA. *NASA Digital Images.* Local Identifiers: 255_GRC_1974_00135 & 255_GRC_1975_02610. Retrieved from https://unwritten-record.blogs.archives.gov/2014/05/30/images-of-the-week-nasa-digital-images, 1974–1975.

NARA. *Photo of Ford Casting Plant Brook Park, Ohio.* ID: 17472660 – Still Pictures, 8601 Adelphi Road, College Park, MD, 20740-6001, 1979.

NARA. *Photo of* Enola Gay *Returning Home After Bombing Hiroshima.* Retrieved from https://catalog.archive.gov/id/7608622, August 6, 1945.

NASA Glenn Research Center. *The Early Years–A Pictorial History.* Retrieved from https://www.grc.nasa.gov/WWW/portal/gallery/jqm/index.html, 2023.

Nakala, Elaine J. *50TH Anniversary–City of Brook Park, Ohio, 1914–1964.* 1964.

UAW Local No. 1250. *The Cleveland Site: History 1950–1997.* 17250 Hummel Road, Brook Park, Ohio 44142, 1997.

USACE Digital Library. *Cleveland Aircraft Assembly Plant.* Retrieved from https://usace.contentdm.oclc.org/digital/collection/p15141coll5/id/517, 1943.